The Samuel H. Kress Study Collection
at the University of Missouri

The Samuel H. Kress Study Collection at the University of Missouri

EDITED BY

Norman E. Land

INTRODUCTORY ESSAYS BY
Osmund Overby and Marilyn Perry

CATALOG ENTRIES BY Burton Dunbar, Norman E. Land,
Judith Mann, Marjorie Och, and William E. Wallace

University of Missouri Press
COLUMBIA AND LONDON

Library of Congress Cataloging-in-Publication Data

University of Missouri–Columbia. Museum of Art and Archaeology.
 The Samuel H. Kress study collection at the University of Missouri
 / Museum of Art and Archaeology, University of Missouri–Columbia ;
 edited by Norman E. Land ; introductory essays by Osmund Overby and
 Marilyn Perry ; catalog entries by Burton Dunbar . . . [et al.].
 p. cm.
 Includes bibliographical references and index.
 ISBN 0-8262-1241-7 (alk. paper)
 1. Painting, Italian Catalogs. 2. Painting, Renaissance—Italy
Catalogs. 3. Kress, Samuel H. (Samuel Henry), 1863–1955—Art
collections Catalogs. 4. Painting—Private collections—Missouri—
Columbia Catalogs. 5. University of Missouri–Columbia. Museum of
Art and Archaeology Catalogs. I. Land, Norman E., 1943– .
 II. Title.
 ND615.U55 1999
 759.5'074'77829–dc21 99-34239
 CIP

⊗™ This paper meets the requirements of the
American National Standard for Permanence of Paper
for Printed Library Materials, Z39.48, 1984.

Text design: Elizabeth K. Young
Cover design: Stephanie Foley
Typesetter: BookComp, Inc.
Printer and binder: Dai Nippon
Typefaces: Formata, New Baskerville

Contents

Comparative Illustrations

Abbreviations

Eisler: Colin Eisler, *Paintings from the Samuel H. Kress Collection: European Schools Excluding Italian.*

Fredericksen and Zeri: Burton B. Fredericksen and Federico Zeri, *Census of Pre-Nineteenth-Century Italian Paintings in North American Public Collections.*

Illustrated Museum Handbook: Osmund Overby, ed. *Illustrated Museum Handbook: A Guide to the Collections in the Museum of Art and Archaeology, University of Missouri–Columbia.* With contributions by J. C. Biers, R. G. Baumann, S. D. Nagar, R. Johnson, and R. E. Witt.

Shapley 1966: Fern Rusk Shapley, *Paintings from the Samuel H. Kress Collection: Italian Schools, XIII–XV Century.*

Shapley 1968: Fern Rusk Shapley, *Paintings from the Samuel H. Kress Collection: Italian Schools, XV–XVI Century.*

Shapley 1973: Fern Rusk Shapley, *Paintings from the Samuel H. Kress Collection: Italian Schools, XVI–XVIII Century.*

Vasari–de Vere: Giorgio Vasari, *Lives of the Painters, Sculptors, and Architects,* trans. Gaston du C. de Vere.

All biblical quotations are from the King James Version.

Preface

The roots of the Museum of Art and Archaeology lie in its teaching mission. Since its official opening on July 1, 1957, the museum has served as a study collection for the Department of Art History and Archaeology and for the University of Missouri as a whole. In 1961, shortly after the museum's inception, the Samuel H. Kress Foundation gave the museum fourteen paintings for a study collection, and the first gallery opened in Ellis Library to display those paintings. This significant contribution was key in establishing the museum as it exists today. These Old Master paintings, which range in date from ca. 1440 to 1760, form the core of the museum's collections of Western art and are displayed prominently in the European and American Gallery in Pickard Hall.

Fern Rusk Shapley (Fig. 7), a loyal alumna, was instrumental in bringing the Kress Study Collection to the university. The museum and its visitors will be forever grateful for her visionary work. The university owes a great deal to the Kress Foundation for its contribution of paintings and funds—both of which further professional expertise in art history and conservation. Like its generous benefactors—Samuel H. Kress (Fig. 1), his brothers Claude W. Kress (1876–1940) and Rush H. Kress (1877–1963), as well as the Kress Foundation and

its trustees—the museum is dedicated to the preservation, conservation, and exhibition of visual culture.

For their generous support, the museum also owes many thanks to Marilyn Perry, president, and Lisa Ackerman, vice president, of the Kress Foundation; and to Diane Dwyer Modestini, adjunct professor, Conservation Center of the Institute of Fine Arts, New York University. Many thanks to Jenny Sherman, associate conservator, Samuel H. Kress Program in Painting Conservation. Ms. Sherman is frequently consulted on conservation issues concerning the Kress Collection.

Former Museum Director Morteza Sajadian and former Curator of European and American Art Christine Neal authored the proposal for funds from the Kress Foundation to conserve the paintings in the study collection, to organize a symposium of national scholars, and to produce this publication.

In conjunction with the thirty-fifth anniversary of the gift from the Kress Foundation, Christine Neal organized a symposium, which was held on April 14, 1996, to present recent findings on the paintings in our Kress Study Collection. Edgar Peters Bowron, senior curator at the National Gallery of Art, Washington, D.C., spoke of Samuel H. Kress's unparalleled

gift of art to America, and Professor Osmund Overby, University of Missouri–Columbia, read a paper that explained the circumstances in which the Kress paintings came to the university. Additional presenters included Professor Burton Dunbar, University of Missouri–Kansas City; Judith Mann, curator of Early European Art, Saint Louis Art Museum; and Assistant Professor Marjorie Och, Mary Washington College. Joan Stack, Ph.D. candidate in art history at Washington University, St. Louis, made a presentation in behalf of Associate Professor William Wallace of Washington University, and Alexandra Huff did so in behalf of Professor Norman Land, University of Missouri–Columbia.

Thank you also to museum staff members Debra Page, associate curator; Matt Averett, research graduate assistant;

and Greig Thompson, chief preparator; and Erin Dalcourt.

A special thanks goes to Press Director Beverly Jarrett, editor Jane Lago, production manager Dwight Browne, and the staff at the University of Missouri Press for their efforts.

We are most grateful to Professor Norman Land for editing this catalog, and to all those who contributed to its completion—Marilyn Perry, Osmund Overby, Marjorie Och, Judith Mann, Burton Dunbar, and William Wallace.

Through the foresight and generosity of one man, Samuel H. Kress, the Museum of Art and Archaeology is forever enriched.

MARLENE PERCHINSKE
Director, Museum of Art and Archaeology

Editor's Preface

For a number of reasons, editing this catalog has been especially enjoyable and rewarding. First, the task presented the opportunity to continue in a small way the work of a distinguished alumna of the Department of Art History and Archaeology, Fern Rusk Shapley (Fig. 7). Along with numerous other scholars, I have long admired and often used her massive three-volume catalog of all the Italian paintings in the Samuel H. Kress Collection. Moreover, as a member of the faculty of the Department of Art History and Archaeology, I am indebted to the Kress Foundation for its gift of the study collection, which I have used for nearly twenty-five years as a resource in teaching numerous courses in Italian Renaissance and Baroque art, and for its contributions to the financial support of the department's graduate program. Another reason this task was so enjoyable is that it offered me the opportunity to acknowledge in a very modest way the tremendous personal debt I owe to the Samuel H. Kress Foundation, which many years ago enabled me to spend two years in Italy working on my doctoral dissertation.

The people with whom I worked on this project also made it exceptionally rewarding. Those who contributed entries on the individual paintings—Burton Dunbar, Judith Mann, Marjorie Och, and William Wallace—have been admirably cooperative, eloquent, and inventive as co-creators of the catalog. Marilyn Perry and Osmund Overby, who wrote the introductory essays, were equally cooperative and generous. Indeed, we owe a special thanks to Dr. Perry for allowing us to republish her article on the history of the Kress Collection, which she revised especially for this publication.

The museum staff was not only helpful and cooperative but also a pleasure to work with. Marlene Perchinske, director, who asked me to carry out the task and helped develop the project to completion, was assisted by Debra Page, associate curator. Jeff Wilcox, registrar, photographed the Museum's Kress paintings, and Scherrie Goettsch provided her editorial expertise. Matthew Averett often lent his assistance and very kindly helped with collecting the photographs for the illustrations.

I am also grateful to Alexandra Huff, who read early versions of some of my entries with a judicious eye and made a number of pertinent suggestions for their improvement, and Eileen Gardner, whose observations on our study collection as a whole have been most helpful.

As always, my gratitude extends to my son, William, and my daughter, Elizabeth, for their unfailing support and good humor.

NORMAN E. LAND

I. INTRODUCTIONS

Five-and-Dime for Millions

The Samuel H. Kress Collection

The history of the Kress Collection is embedded in the history of this century, especially the tumultuous years before, during, and after World War II when continuing economic and political disorder brought vast numbers of European paintings, sculptures, and decorative works onto the international market.[1] As rarely before, and never since, it was possible to amass a collection of European art that in both quality and quantity rivaled the great princely collections. Thus, between 1927 and 1960, a self-made American millionaire (Fig. 1) and his foundation established a collection of Old Master paintings that has been described as one of the most distinguished ever assembled through the resources of a private individual.

Unlike the Frick Collection or the works displayed at the Gardner Museum, the entire Kress Collection has never been on view in one place, a regrettable fact until one analyzes the wisdom of the way in which it was dispersed. In this regard, the Kress Collection is incomparable. There is no permanent Kress Museum, but rather a

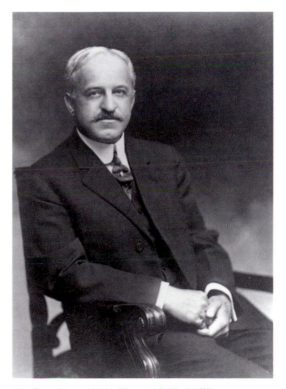

Fig. **1.** *Samuel H. Kress (1863–1955) photographed in the 1920s. (Photo: Samuel H. Kress Foundation)*

1. This is a revised version of an article that appeared in *Apollo Magazine* (March 1991).

lasting gift to the United States that has touched the lives of millions of Americans over the past thirty years. In thirty-three

3

states and territories, more than three thousand works of European art are on display under the label "Samuel H. Kress Collection" in more than ninety museums, universities, and other public institutions from the National Gallery of Art to the Honolulu Academy of Art.

Samuel Kress's generosity as a collector developed along with his collection, which occupied him in earnest from the late 1920s, when he was in his mid-sixties, until he was disabled two decades later. To his contemporaries, the Kress Collection was the crowning achievement of a life that epitomized American opportunity and the virtues of stern discipline, vigorous hard work, and patriotic generosity.

Descended from early German-Lutheran settlers in the Lehigh valley of Pennsylvania, Samuel Henry Kress was born on July 23, 1863, and named for an uncle who had fallen at Gettysburg three weeks before. As a young man he developed an interest in variety-store merchandising, and he opened the first S. H. Kress 5-and-10-Cent Store (appropriating the new scheme pioneered by F. W. Woolworth) in Memphis, Tennessee, in 1896 (Fig. 2). The concept perfectly suited the time. Within a decade, fifty Kress stores were serving the south, and the chain was proliferating westward under the personal supervision of Samuel Kress, who spent months at a time on the road in Pullman sleeping cars. "Shopping at Kress' " became synonymous with quality merchandise at affordable prices, and the "five-and-dime store" became the featured retail (and often social) establishment on the main streets of America. S. H. Kress & Co. incorporated its headquarters in New York City, and its founder enjoyed the rewards of success. Settling in a two-story penthouse apartment on Fifth Avenue designed as a grand Italianate palazzo (Figs. 3–4), he filled its rooms and corridors with

an expanding collection of fine paintings, sculptures, and furnishings imported from Italy. Here he lived, a confirmed bachelor, until his death in 1955.

His evolving interest in Italian art led to the creation in 1929 of the Samuel H. Kress Foundation (in which his younger brothers, Claude and Rush, also participated) to provide for the purchase of works of art and the eventual establishment of a Kress museum. Over the next few years several potential museum sites in the neighborhood of the Frick Collection and the Metropolitan Museum were under consideration. In the meantime, Samuel Kress embarked on a personal project that was to have lasting consequences for the future disposition of the rapidly expanding Kress Collection.

In a long-forgotten gesture of more than sixty years ago, Samuel Kress conceived and underwrote a significant exhibition of Italian paintings from his private collection that traveled across America. According to the accompanying illustrated catalog, the show was personally selected by him. As a donor of paintings to museums around the country, Kress wished to encourage "a more cultured understanding of art" by exhibiting a comprehensive group of Italian pictures arranged geographically and chronologically. The show comprised nine early Sienese panels (by such masters as Pietro Lorenzetti, Sano di Pietro, Matteo di Giovanni), twenty Florentine pictures (including works by Agnolo Gaddi, Neri di Bicci, Piero di Cosimo, Fra Bartolommeo, Pontormo, and Francesco Salviati), a mixed group of works by nine central and northern Italian artists (from Allegretto Nuzi to Pannini and Fra Galgario), and eighteen Venetian paintings (by, among others, the Vivarini, Carlo Crivelli, Dosso Dossi, Lorenzo Lotto, Jacopo Tintoretto, Sebastiano Ricci, Canaletto,

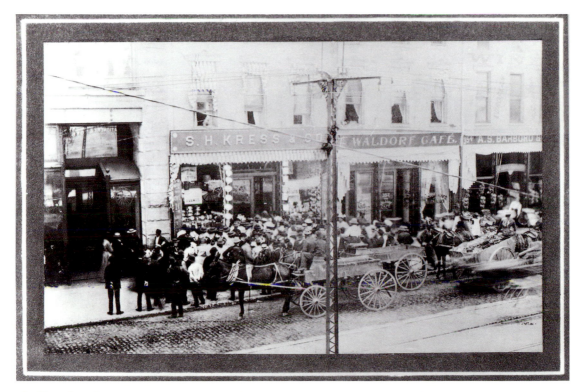

Fig. **2.** *Crowds awaiting the opening of the first S. H. Kress & Co. store in Memphis, Tennessee, on April 18, 1896. (Photo: Samuel H. Kress Foundation)*

and Guardi). Altogether, fifty-three artists were represented.

In the depths of the Great Depression, between October 1932 and June 1935, the Kress exhibition of Italian paintings from the fourteenth to the eighteenth centuries traveled across the country, being shown in local museums and art schools or by courtesy of local colleges and civic organizations. To judge from the yellowed clippings in aged scrapbooks that survive to record the tour, it was a resounding success, not least because of its absolute novelty. The show stopped in twenty-four cities: Atlanta, Memphis, Birmingham, New Orleans, Houston, Dallas, Denver, Colorado Springs, Salt Lake City, Seattle, Portland, Sacramento, San Francisco, Los Angeles, San Diego, San Antonio, Nashville,

Montgomery, Macon, Tampa, Winter Park, Savannah, Charleston, and Charlotte. In none of these cities would it have then been possible otherwise to see more than two or three Italian paintings. Nor was travel widespread in a time of economic desperation. Yet for a few brief weeks, thanks to Samuel Kress, the familiar walls of a local hall were filled with the whole history of Italian painting. From the point of view of our own frenetic age, when air travel is endemic and there is always too much to see, it is difficult to imagine the excitement generated by the Kress exhibition.

The Kress paintings traveled by train, accompanied constantly by an agent responsible for safety, display, and packing, who faithfully corresponded with Samuel Kress in New York. Although each venue

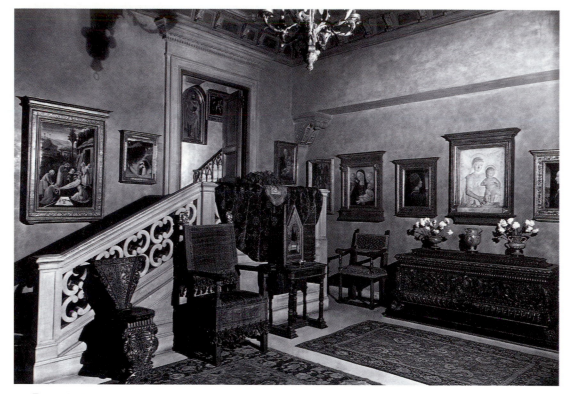

Fig. **3.** *The hallway of the Kress apartment at 1020 Fifth Avenue, New York, before the donation of the Italian painting and sculpture to the National Gallery of Art in 1939. (Photo: Samuel H. Kress Foundation)*

was also the home of a Kress store, the letters between Kress and his agent belie any commercial motive and confirm the collector's deep personal interest both in the works of art and in the public response. From time to time, depending upon audience reaction, Kress would also donate a painting to a local museum, for the perpetual enjoyment of the public.

As with so much else in the Kress story, neither Kress's traveling exhibition nor his widespread donations find any parallel in the annals of great American collectors. Nor will it ever be possible to assess the full effect of his philanthropy. For example, Kress's 1931 donation of a large panel painting of the *Madonna Enthroned* *between Saint Nicholas and Saint Paul* by Luca di Tommé to the then Los Angeles Museum of History, Science, and Art was announced in a museum publication with the heading, "The Renaissance Begins in Los Angeles." Praise for Kress's generosity as a merchant prince of the New World concluded with the remark: "The art collections of the world have been created under such guidance and in time Los Angeles as the fourth city in the Union will have collections of art worthy of her position." Time and again, throughout the 1930s, grateful museums acknowledged the receipt of major paintings—a Lorenzo Lotto in Houston, a Sebastiano and a Marco Ricci in Savannah, a portrait attributed

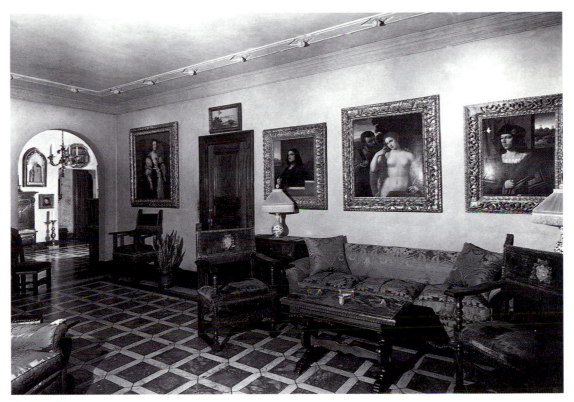

Fig. **4.** *The Kress apartment at 1020 Fifth Avenue. The paintings on the wall are of the late fifteenth-century Venetian School. (Photo: Samuel H. Kress Foundation)*

to Dosso Dossi in Wichita—as Samuel Kress's habitual generosity placed no fewer than eighty-six paintings in thirty-nine museums, schools, and churches across the country.

Believing in the vision of sharing his collection with the American public, Samuel Kress became one of the founding benefactors of the new National Gallery of Art in 1939. Created through the inspired vision and beneficence of Andrew Mellon, the vast and resplendent marble temple for art on Washington's Mall was soon to be dedicated to the nation. Congress guaranteed maintenance of the building, but its treasures were to be the gifts of private donors. Around the nucleus of the great masterpieces of the Mellon Collection were grouped 386 Italian paintings and 24

Italian sculptures from the Kress Collection in New York.

The National Gallery of Art was inaugurated by President Franklin D. Roosevelt on March 17, 1941. His speech acknowledged the importance of art and of preserving the art of the past, as representing the freedom of the human spirit, now menaced and crushed by the European war. He praised the donors for understanding that "great works of art have a way of breaking out of private ownership into public use." In concluding he promised, "The dedication of this gallery to a living past, and to a greater and more richly living future, is the measure of the earnestness of our intention that the freedom of the human spirit shall go on."

In his turn, Samuel Kress expressed regret that Andrew Mellon had not lived to see his dream realized. He noted, "Like Mr. Mellon, I also felt the need of a National Gallery, which would be shared by all the people of our country, and contain only the finest works of art, contributed by those who wished to give their greatest treasures to the Nation that has done so much for all of us." His own collection, he continued, was formed "to provide for the study and enjoyment of the public, as complete a representation as possible of the Italian School of painting and sculpture of quality. I have endeavored to acquire the best examples of the most representative masters of this important school, beginning with the thirteenth-century painters Giotto and Duccio, and extending through the great periods of Florence, Siena, Umbria, Venice and Northern Italy, and ending with the Venetians of the eighteenth century." He would miss his Italian paintings, the walls of his home would be bare, "But I am happy in the thought that, during my lifetime, my collection is intact and settled in my country, in a permanent home within this magnificent modern structure. . . . And so, Mr. President, I turn over my collection to you for the benefit and enjoyment of all the people, to be preserved as part of that spiritual heritage, which is our greatest and most treasured possession."

A few years after this momentous event Samuel Kress was severely incapacitated by a grave illness from which he never recovered. Responsibility for the Kress Foundation—and for the Kress Collection— was assumed by his surviving younger brother, Rush, under whose direction the Kress Collection began the great phase of its final distribution.

Noteworthy is the fact that in both the traveling exhibition and the donation to the National Gallery of Art, Samuel Kress focused exclusively upon the Italian paintings that were the heart of his collection, and for which he had established the guiding principle of selecting representative works of all the major painters and schools. Throughout the 1930s, however, he also collected paintings by non-Italian masters. In fact, the nearly four hundred Kress paintings that graced the National Gallery of Art at its opening in 1941 (part on loan and part as permanent gifts) constituted less than half of the still-expanding Kress Collection.

The collection continued to grow after the war, as the Kress Foundation acquired works to enrich and balance the collections of the National Gallery of Art—especially the non-Italian schools— through an arrangement that replaced previous Kress loans with new ones. The Kress Collection increased its scope to include major works by Dürer, Cranach, and Grünewald; early Netherlandish pictures by Hans Memling and Hieronymus Bosch; and even a painting (a donor portrait by Petrus Christus) once owned by Amerigo Vespucci. These were joined by works by the Flemings Rubens and van Dyck, by great seventeenth-century Dutch masters, and by a virtual *musée de l'art français* from the Maître de Saint Gilles and Clouet to Poussin, Claude, Watteau, Fragonard, Boucher, Chardin, David, and Ingres. Other purchases secured some of the most important El Grecos in America, the great *retablo* from Ciudad Rodrigo that is Fernando Gallego's masterpiece, and works by Murillo, Zurbarán, and Goya. Moreover, the collection of masterpieces of the Italian schools continued to grow, eventually encompassing more than a thousand works by 342 identifiable painters. The list of artists represented in the Kress Collection comprises almost a complete catalog of continental European art (with the curious

exception of Dutch cabinet pieces) from the thirteenth to the early nineteenth centuries.

The Kress Foundation also acquired important works of European sculpture—by Donatello, Bernini, Houdon, Clodion—along with the superlative Dreyfus collection of more than thirteen hundred small bronzes, medals, and plaquettes. For the Metropolitan Museum of Art, the foundation purchased the great Robert Adam room from Croome Court in Worcestershire, with original furnishings that include Gobelin tapestries of designs by Boucher. Other gifts to the Metropolitan included the Hillingdon Collection of fine French furniture and porcelain and a major donation of period Italian frames. The resplendent series of thirteen tapestries of the *Acts of Constantine the Great,* designed by Rubens and Pietro da Cortona for the Palazzo Barberini in Rome, was reassembled by the Kress Foundation and donated to the Philadelphia Museum of Art, where it hangs around the great hall.

For the most part, however, the Kress Foundation purchased paintings. To care for the collection, an elaborate facility for the conservation of paintings was created at Huckleberry Hill, a Kress estate in the Pocono Mountains of Pennsylvania, and staffed by a team of Italian conservators led by Mario Modestini. Exacting records of conservation treatment and other information regarding the collection were gathered at the foundation's headquarters in New York, where the Viennese art historian William Suida helped to compile the earliest Kress catalogs.

It was an extraordinary time. Continuing the pattern of generosity and vision established by his brother, Rush Kress guided the foundation in developing programs designed to share the Kress Collection with the nation in the widest possible way. Eighteen municipal museums across the country—in Allentown, Atlanta, Birmingham, Columbia, South Carolina, Coral Gables, Denver, El Paso, Honolulu, Houston, Kansas City, Memphis, New Orleans, Portland, Raleigh, San Francisco, Seattle, Tulsa, and Tucson—were invited to select a core collection of thirty to sixty Old Master paintings each from the Kress reserves. Museum directors visited New York and Huckleberry Hill to view paintings and weigh choices, as new acquisitions were made or paintings were rotated out of the National Gallery. Local pride in these gifts led to the construction of new air-conditioned rooms to accommodate the Kress paintings, as well as two entirely new museums. By the end of the 1950s, the Kress Foundation had placed more than seven hundred examples of European painting, sculpture, and decorative arts in American communities.

Nor was this the limit of the generosity. Recognizing the importance of making art accessible within a learning environment, the foundation in the early 1960s distributed a final group of 271 paintings from the Kress Collection to eight American colleges (Amherst, Berea, Bowdoin, Oberlin, Pomona, Trinity, Vassar, and Williams) and fourteen universities (Arizona, Arizona State, Bucknell, Chicago, Georgia, Harvard, Howard, Indiana, Kansas, Missouri, Nebraska, Notre Dame, UCLA, Vanderbilt, and Wisconsin). In this context the Museum of Art and Archaeology at the University of Missouri–Columbia received a gift of thirteen Italian paintings (including a devotional cross) from the fifteenth to the eighteenth centuries and an early copy of Rembrandt's *Sacrifice of Isaac* (Cat. No. 14). Typical of other Kress Study Collections, the pictures in Columbia—altarpieces, portraits, sacred and mythological images, and genre pieces—provide the university community with works of art that encapsulate

the past for the present and with objects that have been treasured for centuries bring history to life.

The distribution of the Kress Collection was largely accomplished by 1960. To mark the formal conclusion of the process, an exhibition of selected Kress paintings from the regional galleries—"Art Treasures of America"—was mounted at the National Gallery of Art, with a presentation ceremony held on December 9, 1961. On behalf of the board of the National Gallery, Chief Justice of the United States Earl Warren welcomed the invited guests and praised the munificence of the Kress Foundation, whose gifts to the National Gallery "now fill almost a third of the exhibition space in this building." Echoing President Roosevelt's sentiments of twenty years before, he also spoke of the need to nurture the human spirit in an age of anxiety: "The Trustees of the Samuel H. Kress Foundation have recognized the importance of art in the life of every human being. As a result of the gifts, which will be made here this evening of these collections of painting and sculpture, millions of people will gain an insight into values that lie beyond the reach of time."

Dr. Franklin D. Murphy, the chancellor of the University of California at Los Angeles, spoke as chairman of the executive committee of the Kress Foundation and presented "deeds of gift" to the directors of the eighteen regional galleries. He characterized the bold vision of Samuel H. Kress, who, "at once vigorous, determined, sensitive and imaginative, . . . dared dream that Americans from Washington to Honolulu, and from New York to El Paso, would have the opportunity to explore the genius of the artist in qualitative terms and at first hand." This objective was accomplished in "The Kress Gift to the Nation," which would now bring "to the American people, both in breadth and in depth, a significant segment of the artistic flowering of western Europe." Not only the National Gallery of Art and the eighteen regional galleries would benefit from the Kress donation but also twenty-two college and university galleries, in recognition of their important role in training the curators, artists, and connoisseurs of the future.

In describing the amplitude of the Kress Collection—approximately fourteen hundred paintings, a hundred and fifty sculptures, thirteen hundred bronzes, the Barberini tapestries, the Croome Court room, the French decorative works, a unique collection of Piazzetta drawings, and many other miscellaneous but important objects—Murphy observed, "What we do here tonight is comparable to few other such acts in history—indeed, it invokes the memory of the day when Anna Maria Louisa of Tuscany and the Palatinate so richly endowed the Tuscan State."

Responding for the assembled museum directors, Richard A. Harvill, president of the University of Arizona, which was awarded both a regional collection and a study collection, accepted the Kress gift with gratitude on behalf "of the people of the United States to whom these gifts are actually made. . . . The great Kress Collection is not really divided. It is still the Kress Collection. It belongs to the American people as it was always intended that it should. . . . The actual presence of fine examples from the great tradition of European art in a community *as a possession of that community* will become a pervasive influence toward understanding and appreciation of the meaning of art in the life of a people."

An unprecedented, unrepeatable episode in the history of Western art, and in the history of American philanthropy, was formally concluded. During the next decade and a half, an international team

of art historians, commissioned by the Kress Foundation, compiled a comprehensive nine-volume catalog of the Kress Collection—a *musée imaginaire* that takes the physical measure of this incomparable gift. The spiritual effects of Samuel Kress's generosity are beyond documentation.

MARILYN PERRY
President, Samuel H. Kress Foundation

The Kress Study Collection Comes to the University of Missouri

The Samuel H. Kress Foundation's gift of works of art to the nation remains unequaled in the cultural life of the United States. First, the foundation made a very substantial gift to the National Gallery of Art in Washington, D.C.; then, it gave smaller collections to eighteen museums spread from the East Coast to Hawaii. In addition, it presented substantial groups of decorative arts to the Metropolitan Museum of Art in New York and to the Philadelphia Museum of Art.

As the foundation was completing the work of organizing the gifts to institutions, about two hundred paintings and sculptures had not found an appropriate place in any collection. They were in no way leftovers; indeed, some were works of great importance. Faced with this situation, the trustees of the Kress Foundation approved the distribution of works through the Study Collection Program. These gifts went to colleges and universities that were known to emphasize the teaching of art history and would be able to enhance existing collections or form new ones around the available works. Under this program the fourteen wonderful Renaissance and Baroque paintings—all but one Italian—composing the Samuel H. Kress Study Collection at the University of Missouri came to the Museum of Art and Archaeology.[1]

Obviously, with only twenty study collections available, the competition for them was stiff. Why, then, was the University of Missouri chosen to receive such a collection? The answer is that the university had the right combination of a strong tradition upon which to build and promising new resources for the future. Serendipitously, there were also important personal connections between the Kress Foundation and the Department of Art History and Archaeology.

Art history and archaeology have been taught at the University of Missouri since 1892, when John Pickard (Fig. 5) joined the faculty, one of a large number of crucial appointments made by President Richard Henry Jesse. Pickard's appointment put the university in the front ranks of the modern research universities then making their appearance in the United States. Walter Miller (Fig. 6), an archaeologist and the first American to excavate in Greece, had joined

1. See Edward A. Maser, "The Samuel H. Kress Study Collection Program."

12

Fig. **5.** *John Ankeney (?).* Portrait of John Pickard (1858–1937). *Oil on canvas. Department of Art History and Archaeology, University of Missouri–Columbia.*

Fig. **6.** *Walter Miller (1864–1949).*

the department of classics the year before. Pickard immediately began assembling objects for the teaching of art history. In subsequent summers he traveled to major museums in Europe ordering plaster casts of famous works of sculpture; most of the works were Greek, but some later ones were included as well. The cast gallery, now housed in Pickard Hall, is extremely rare among university collections and is highly prized by many segments of the community. Pickard also began to collect other teaching aids—slides and photographs, oil copies of famous paintings, and a number of prints that are now in the collections of the Museum of Art and Archaeology. Other than the prints, only a few of the objects collected by Pickard can be called original works of art, but all of them were nicely installed

in the newly completed Academic Hall, later to be renamed Jesse Hall. Pictured in the yearbook, *Savitar,* for 1895–1896, the collection was identified as the Museum of Classical Archaeology and History of Art.[2]

Three of Pickard's students had particularly distinguished careers as art historians. John Shapley, who received a bachelor's degree from the University of Missouri in 1912, a master's degree from Princeton in 1913, and a doctoral degree from the University of Vienna in 1914, returned briefly to the University of Missouri to serve as Pickard's assistant before going on to teach at several other academic institutions.

2. For this history, see Allen Stuart Weller, "John Pickard, Walter Miller, the College Art Association of America, and the University of Missouri." When Pickard retired in 1929, Weller succeeded him, remaining at the University of Missouri until after military service in World War II, when he moved to the University of Illinois.

Fig. **7.** *Fern Rusk Shapley (1890–1984).*

Pickard was one of the founders of the College Art Association in 1912 and from 1914 to 1919 served as its second president. Shapley was elected the fourth president of the College Art Association and served in that position and as editor of the *Art Bulletin* from 1921 to 1939. Fern Rusk (Fig. 7), who later married John Shapley, received a master's degree under Pickard in 1914 and a Ph.D. in 1916. She spent some years in Italy at I Tatti, Bernard Berenson's villa outside Florence, where she assisted him in preparing the amplified edition of *The Drawings of the Florentine Painters*. Later, she would play an important part in bringing the Kress Study Collection to the university. The third student was Blake-More Godwin, who served for many years as director of the Toledo Museum of Art in Ohio and in whose memory a lecture fund has been

established in the Department of Art History and Archaeology at the university.

In the late 1930s, a young student from Kansas City named Homer Thomas came to the University of Chicago as an undergraduate to study art history. John Shapley, who was then a member of the art history faculty at Chicago, quickly sized up the young student, found a fellowship for him, and sent him on to Bernard Berenson's villa near Florence and the tutelage of Fern Rusk Shapley. Two years later, after stays at other research centers in Europe, Homer Thomas returned to Chicago, where John Shapley enrolled him in the graduate program at the University of Chicago, even though he had no baccalaureate degree. The Second World War intervened with duty for the Secret Service, and only after the war did Homer Thomas receive a doctoral degree from the University of Edinburgh, Scotland.

In 1948, following the war, Saul S. Weinberg and Gladys D. Weinberg (Fig. 8), each with a doctoral degree from Johns Hopkins University, arrived in Columbia. Saul Weinberg accepted a position at the University of Missouri in the department of classics. Two years later Homer Thomas became professor of art history in the art department. They soon teamed up to reconstitute Pickard's old program in art history and archaeology, and while Professor Weinberg served as chair of the new department, Professor Thomas concentrated on building the library collections. They organized the various materials, the Cast Gallery in particular, to make them available for study and teaching once again. In 1957 the university approved a new budget item for "Study Collections for Art History and Archaeology," an approval that marked the beginning of the present museum.

In the meantime, Fern Shapley, who had recently retired as assistant chief

Fig. **8.** *Saul Weinberg (1911–1992) and Gladys Weinberg (1909–).*

curator of the National Gallery of Art in Washington, became curator of research for the Samuel H. Kress Foundation, still based at the National Gallery. The Shapleys, loyal alumni, kept in touch with the Thomases and soon knew the Weinbergs as well. In addition to her ongoing studies of the works in the vast Kress holdings, Fern Rusk Shapley was primarily responsible for the curatorial task of determining how to distribute the Kress Collection around the country. The University of Missouri, with its long tradition for teaching art history now reconstituted, and with the promise of a museum unfolding, was just the kind of institution the Kress Foundation was seeking for its Study Collection Program. Guy Emerson, the art director of the Kress Foundation, in a letter of March 16, 1961, formally offered the Kress Study Collection to the University of Missouri. On April 11, after the paintings were installed

in Columbia, Fern Rusk Shapley visited her alma mater to make the official presentation in behalf of the Kress Foundation. She also prepared the first serious article about the collection, which was published in the *Missouri Alumnus* magazine the following month.[3]

With the presentation of the Kress paintings, what had been known as the Study Collections for Art History and Archaeology became the Museum of Art and Archaeology. Saul Weinberg served as the director of the new museum and regularly published articles about its activities in the university's alumni magazine. In 1967, the museum's own journal, *Muse, the Annual of the Museum of Art and Archaeology,* was inaugurated under the editorship of Gladys Weinberg. With strong support from President Elmer Ellis and other senior administrators, the museum collections continued to grow. The three small galleries the museum occupied on the fourth floor of Ellis Library (Fig. 9) became ever more crowded. Finally in the early 1970s plans were developed to move the museum and the Department of Art History and Archaeology into larger quarters in the recently vacated old Chemistry Building on Francis Quadrangle.[4] The exterior was carefully preserved while the interior was renovated for the new functions the building would serve. In the fall semester of 1975, the department moved in. A year later the museum followed, moving the Kress Study Collection and other related works that had been added since 1961 into a splendid new gallery. At the suggestion of Fern Rusk Shapley, the building was named in honor of John Pickard. She was the featured speaker at a gala dedication

3. Fern Rusk Shapley, "Valuable Art Collection for the University."
4. See *Illustrated Museum Handbook,* 129–31.

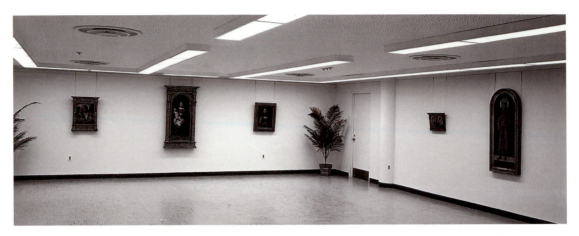

Fig. **9.** *Part of the Samuel H. Kress Study Collection as it was exhibited in the fourth floor of Ellis Library, University of Missouri–Columbia, 1961.*

dinner, where she recalled her student days and Pickard's reputation as "the Apostle of Beauty to the Middle West." It was certainly appropriate to have the Kress Study Collection in a building named for John Pickard, because it was Italian Renaissance art above all else that had set the standard of beauty for his generation.

Osmund Overby
Professor Emeritus, Department of
Art History and Archaeology
University of Missouri–Columbia

II. CATALOG

An Overview of the Collection

Our portion of the Samuel H. Kress Study Collection, which comprises fourteen paintings, all but one Italian in origin—the exception is a copy of a work by Rembrandt (Cat. No. 14)—is representative of the chronological development of styles in Italy from the Gothic period to the eighteenth century and demonstrates the geographical diversity of Italian art over the same centuries.

The earliest of the paintings, Michele di Matteo's companion panels *Virgin Mary* and *Saint John the Evangelist* (Cat. No. 1), date to ca. 1440 and display a linear elegance and gracefulness that are the hallmark of the Gothic style. Moreover, their style exemplifies the manner of the art of the geographical location in which they were made. In those two panels the "intense, tragic expression of the faces is typical of the early Bolognese school, as is the lovely translucent coloring."[1]

The style of the Early Renaissance is less about the kind of linear beauty found in Michele di Matteo's panels and more about the faithful depiction of nature. This style is represented in the paintings by "Alunno di Benozzo" (Cat. No. 2), a follower of the Florentine painter Benozzo Gozzoli; by an anonymous Veronese master (Cat. No. 3); by the Sienese Bernardino

Fungai (Cat. No. 4); by Giovanni Francesco de' Manieri from Parma (Cat. No. 5); and by Bartolommeo Montagna from Vicenza (Cat. No. 6). Montagna's painting of ca. 1510, however, especially in the landscape, already demonstrates something of the greater naturalism in works by artists whom we associate with the High Renaissance in Venice, such as Giorgione and Titian.

High Renaissance art is not only more naturalistic in style than quattrocento art, it also embodies a greater idealization of form, largely derived from examples of ancient Greek and Roman sculpture. This style can be seen in works by Leonardo da Vinci, Raphael, and Michelangelo, but also in the paintings of such provincial artists as Romanino from Brescia (Cat. No. 7), Altobello Melone from Cremona (Cat. No. 8), and Bramantino from Milan (Cat. No. 9), all three of which works were created around 1520. Some Venetian artists of the mid-sixteenth century, such as Jacopo Tintoretto and Paris Bordone (Cat. No. 10), combined elements of the High Renaissance style with features from the style now referred to as Mannerism. In other words, the idealized and essentially classical beauty of Bordone's figures coexists with the grace and mannerism of their movement and gesture, all of which occurs in a shallow and indeterminate space.

1. Shapley, "Valuable Art Collection," 1.

19

The Baroque period is represented by two paintings, a copy, possibly by a Dutch artist, of Rembrandt's *Sacrifice of Isaac* (Cat. No. 14), with its dynamic composition and dramatic portrayal of the narrative, and the imposing *Portrait of Giovanni Battista Silva* (Cat. No. 11) attributed to the Milanese painter Carlo Francesco Nuvolone, which, like other works from the seventeenth century, invites the viewer to almost physically interact with the figure. Giuseppe Bazzani's *A Laughing Man* (Cat. No. 12), although painted in eighteenth-century Mantua, is nevertheless "baroque" in its dramatic presentation of a single figure and, again, in the way in which it physically involves the viewer. Last, the delicate loveliness of Pietro Rotari's *Young Woman with a Sprig of Jasmine* (Cat. No. 13) is characteristic of the Rococo phase of eighteenth-century art as it was practiced by a northern Italian artist who had knowledge of French art and lived in Russia.

In addition to style, chronology, and place of origin, the Kress paintings may be examined in terms of their subject matter. For example, there are three portraits in the collection, although only one of them (Cat. No. 11) conforms to conventional expectations of the genre. That is, while Nuvolone's portrait is both a likeness of an identifiable person and a revelation of his character, personality, and social station, in the "portraits" by Bazzani (Cat. No. 12) and Rotari (Cat. No. 13) the focus is not on the specific identity of the figure but on a type, "crazed man" and "attractive woman," respectively.

Excluding the portraits, all of the paintings, save one, represent Christian themes. The exception is Paris Bordone's *Athena Scorning the Advances of Hephaestus* (Cat. No. 10), which draws upon a story from ancient literature for its subject matter. In the seventeenth century, the copy after Rembrandt (Cat. No. 14), although representing a scene from the Pentateuch, Abraham's near-sacrifice of Isaac, would have been understood by Christians as a kind of foreshadowing of God's sacrifice of his son, Jesus. The *ex voto* panel attributed to Manieri (Cat. No. 5), though not directly Christian in subject matter, contains the inscription of a prayer addressed to the Virgin Mary in gratitude for deliverance from a serious illness. The remaining paintings contain images of God the Father, Christ, the Virgin Mary, and Christian saints, as well as Satan in the guise of a beautiful woman (Cat. No. 6).

Like Satan, God the Father is present only once (Cat. No. 2), but Christ appears in several of his traditional types—as a child in the arms of his mother (Cat. Nos. 3, 8, and 9); as a crucified adult (Cat. No. 2); as the Man of Sorrows (Cat. No. 3); and as the Savior (Cat. No. 7). The Virgin Mary is in five of the paintings, three times with the infant Jesus (Cat. Nos. 3, 8, and 9) and twice (Cat. Nos. 1 and 2) as the grieving mother of the crucified Christ. Four saints are represented: John the Evangelist (Cat. Nos. 1 and 2), Anthony of Egypt (Cat. No. 6), Catherine of Siena (Cat. No. 2), and either Louis of Toulouse or Sigismund (Cat. No. 4).

The Kress paintings may also be studied with regard to their function. Although the subject matter of Bordone's painting was certainly important to Renaissance viewers, it might have been displayed with a companion (Fig. 24) over a doorway in the palace of a private patron, and in that case would also have been valued as domestic decoration.[2] Because we do not know the circumstances surrounding the creation of the copy after Rembrandt (Cat. No. 14), we can only speculate about its original function. The painting could have

2. Ibid., 3.

been ordered by a patron who admired Rembrandt's original but could not own it, and therefore had a copy made of it. Or the painting might be the work of an artist who wanted to learn the "secrets" of Rembrandt's style.

Several of the paintings are fragments of larger religious works and originally would have been viewed within the setting of a church or chapel and often within the context of public worship. The panels by Fungai (Cat. No. 4) and Melone (Cat. No. 8) at one time belonged to the main portion of an altarpiece, while Montagna's painting (Cat. No. 6) was one of a series of panels in a predella. The small banner, or *stendardo* (Cat. No. 3), by an anonymous Veronese artist would have been attached to a pole and carried during religious processions. The half-length figures by Michele di Matteo (Cat. No. 1) once belonged to either an altarpiece or, more likely, a devotional cross. Crosses, like the one by a pupil of Gozzoli (Cat. No. 2), were often set up in churches and chapels but also could be found in private dwellings, where they were used for individual devotion. The relatively small size of Bramantino's *Madonna and Child* (Cat. No. 9) and Romanino's *Christ Blessing* (Cat. No. 7) suggest that they, too, were objects used for personal devotions. Manieri's *ex voto* painting (Cat. No. 5), which is a kind of thank-offering from the patron to Virgin Mary for sparing his life, is a special instance of the personal use of religious images. The grateful worshiper probably would have placed the panel on or near an altar where it would have, as it were, prayed for the donor in perpetuity.

Our paintings also help us to understand the importance of the viewer in the Renaissance and Baroque periods. Several of the figures look out toward the viewer, but not all with the same effect. Michele di Matteo's figures (Cat. No. 1), who originally would have mourned the death of Christ, look out at the viewer as if inviting him or her to feel what they feel. Here we might recall the advice Leon Battista Alberti gave to painters in his book *On Painting* (1435), written at about the same time Michele di Matteo was making his panels: "I like there to be someone in the 'historia' who tells the spectators what is going on, and either beckons them with his hand to look, or with ferocious expression and forbidding glance challenges them not to come near, as if he wished their business to be secret, or points to some danger or remarkable thing in the picture, or by his gestures invites you to laugh or weep with them."[3]

The figure of Saint Catherine in the lower quatrefoil of the devotional cross (Cat. No. 2) stares directly at the viewer as she displays her stigmata. Other figures that gaze steadily at the viewer can be found in the paintings by Romanino (Cat. No. 7), Melone (Cat. No. 8), Bramantino (Cat. No. 9), Nuvolone (Cat. No. 11), Bazzani (Cat. No. 12), and Rotari (Cat. No. 13). The gaze of Rotari's beautiful young woman is not confrontational but inviting and even seductive, while Bazzani's figure seems to leer threateningly at the viewer.

Some of the paintings involve the viewer in a way other than through the gaze of the figure. For example, in Romanino's *Christ Blessing* (Cat. No. 7), Melone's *Madonna and Child Enthroned* (Cat. No. 8), and perhaps Bramantino's badly rubbed *Madonna and Child* (Cat. No. 9), the light illuminating the pictorial space has its source outside the painting. In each case the light emanates from an imaginary place behind the left

3. Leon Battista Alberti, *On Painting and on Sculpture*, 82–83. For a brilliant discussion of art in relation to its viewer, see John Shearman, *Only Connect . . . : Art and the Spectator in the Italian Renaissance*. See also Norman Land, "Carlo Crivelli, Giovanni Bellini, and the Fictional Viewer."

shoulder of the viewer.[4] By such means, the artist creates an implied or imaginary space in front of the picture. The viewer, when standing before the work of art, simultaneously occupies that imaginary space and the actual space of the room in which the picture is exhibited. In other words, the viewer is literally in the world of ordinary reality and imaginatively in the light of the picture. In works with a Christian subject matter, this standing in the light would have had profound significance. The device, however, was not confined to religious paintings or to the Renaissance, for later both Nuvolone (Cat. No. 11) and Rotari (Cat. No. 13) employed it in their portraits.

Another aspect of Renaissance and Baroque art that may be studied in our collection is the importance of inscriptions. One of the most popular topics of discussion from the sixteenth century onward was the *paragone,* or comparison of art and poetry. Poets, of course, tended to champion verbal expression as the superior means of communication, whereas artists held that images have a far more powerful effect.[5] Nevertheless, in countless paintings created during the same centuries, visual images are frequently accompanied by verbal inscriptions. These inscriptions can be as simple as the Greek letters *alpha* and *omega,*

held by God in the top quatrefoil of the devotional cross (Cat. No. 2), or as complex and extended as the prayer in the *ex voto* attributed to Manieri (Cat. No. 5). Indeed, the central meaning of the votive panel is in the writing it contains. The inscription on the paper held by the sitter in Nuvolone's portrait (Cat. No. 11) not only identifies the sitter but, as we have already suggested, also engages the viewer. Regardless of Renaissance and Baroque theories about art and poetry, the act of looking at a painting often involved reading as well.

To call the Kress paintings a "study" collection is to acknowledge their intended use, to instruct, but the word also implies that the contribution of each work to the history of art, as we now understand it, is very limited. However, we do not want to overlook the fact that each and every work of art, even the most modest, from the Renaissance or any other period in art history, offers a unique experience for the viewer. One work may have a certain beauty, another, a curious inscription, and still another, an unusual color or engaging expression. If we ignore those works and the experiences they offer, concentrating only on the masterpieces, we miss a great deal of the variety and breadth that art has to offer.

NORMAN E. LAND

4. See Michael Schwartz, "Beholding and Its Displacements in Renaissance Painting," 236.

5. For a recent discussion of art and literature (with further bibliography), see Norman E. Land, *The Viewer as Poet: The Renaissance Response to Art,* 3–24.

1 Michele di Matteo da Bologna

Bologna: active 1410–1469

Saint John the Evangelist and *Virgin Mary* (ca. 1440)

Tempera and gilt on wood panel. Left panel: 24.8 × 16.8 cm; right panel: 24.8 × 17.2 cm. Museum of Art and Archaeology, University of Missouri–Columbia (61.81), Samuel H. Kress Collection (K 1195).

Provenance: De Clemente Collection, Florence; Cavaliere Enrico Marinucci Collection, Rome; Contini-Bonacossi Collection, Florence; Samuel H. Kress Collection (1939).

Exhibited: "Selections from the Museum of Art and Archaeology, University of Missouri–Columbia," University of Missouri–St. Louis, February 21–March 15, 1979, no. 56.

Literature: Shapley 1966, 73; *Illustrated Museum Handbook*, 72; Fredericksen and Zeri, 142.

There is no definitive description of the life and career of the Bolognese painter who signed an altarpiece for the Church of Sant'Elena in Venice (Fig. 10) as follows: *Michael Mathei da Bononia F[ecit]* (Michele [son of] Matteo from Bologna made [this]).[1] Nevertheless, some scholars believe that the earliest reference to this Michele di Matteo was in 1410, when, with an artist named Francesco Lola (1393–1419), he designed some banners (*stendardi*) for the arrival in Bologna of the antipope Alexander V. In 1428 he worked with Giovanni da Modena, who was

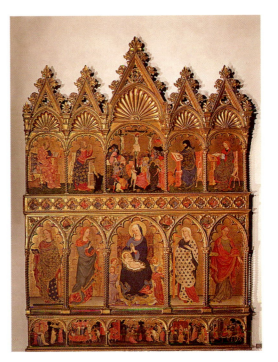

Fig. **10.** *Michele di Matteo.* Altarpiece. *Tempera on wood. Gallerie dell'Accademia, Venice. (Photo: Art Resource)*

active in Bologna from 1409 to 1456 and painted in a late Gothic style. At some time during the period from ca. 1430 to 1437, Michele supposedly made a trip to Venice, where he painted the above-mentioned polyptych for the church of Sant' Elena. In Venice he would have encountered the works of such renowned International Gothic artists as Gentile da Fabriano, Zanino di Pietro, Jacobello del Fiore, Jacopo Bellini, and Michele Giambono.

In *Virgin Mary* and *Saint John the Evangelist*, the elegant, flowing lines of the mantles and the pseudo-Arabic designs in their borders echo similar features in the Sant'Elena altarpiece (Fig. 10).[2] Nevertheless, our two

1. For a convenient discussion of Michele di Matteo and his works and for further bibliography, see *Dictionary of Art*, 21:461–62.

2. For the attributions of our panels to Michele di Matteo, see Shapley 1966, 73, who dates them to ca. 1440. See also Richard G. Baumann in *Illustrated Museum Handbook*, 72.

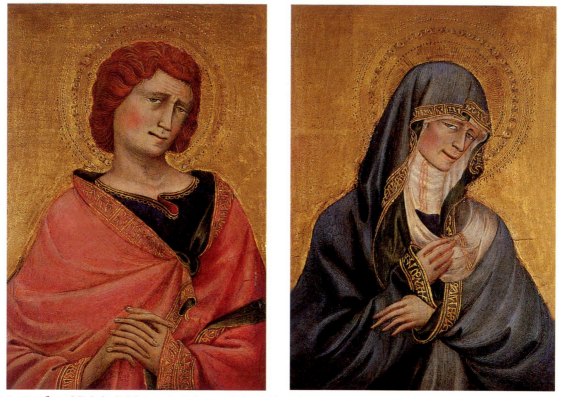

Cat. No. **1.** *Michele di Matteo da Bologna.* Saint John the Evangelist *and* Virgin Mary. *Museum of Art and Archaeology, University of Missouri–Columbia; Gift of the Samuel H. Kress Foundation.*

figures bear a much stronger, morphological resemblance to the figures in a *Crucifix* attributed to Michele in the Pinacoteca Nazionale, Bologna (Fig. 11). Specifically, there is a similarity in the treatment of the hair and eyebrows, as well as in the shape of the head and the eyes of the figures. Other similarities are the way in which the eyes have been created with two strokes of black paint; the black line along the contour of the face; and the way in which the tunic of Saint John in each case makes an S-shaped fold in the neckline. Most telling, however, are the thick, black line used to divide the upper and lower lips of the mouth and the U-shaped fold in the skin at the top of the nose between the eyebrows—features that are almost the same in each work.

Our panels are also comparable in style to certain paintings attributed to Zanino di Pietro, who is known to have worked in Bologna and then in Venice.[3] The paintings by Zanino that seem to date to ca. 1420 are in the iconostasis (or decorated altar screen) of the cathedral (Santa Maria Assunta) at Torcello, an island near Venice. For example, we find in our figure of Saint John the Evangelist and in the figures at Torcello (Fig. 12) a similar thick black line used to divide the upper and lower lips of the mouth and the same U-shaped fold in the skin at the top of the nose. There is, however, an

3. For recent studies of Zanino di Pietro and his work and for further bibliography, see *Dictionary of Art,* 33:614, and Sonia Zanon, "Documenti d'archivio su Zanino di Pietro."

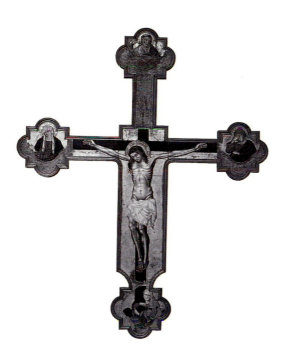

Fig. **11.** *Michele di Matteo*. Crucifix. *Tempera on wood. Pinacoteca Nazionale, Bologna. (Photo: Art Resource)*

important difference in style between the figures at Torcello attributed to Zanino and our figures by Michele—namely the quality of line, which in our panels is of a greater elegance and facility. Thus, we could say that the style of Zanino's panels belongs to the fourteenth century, while that of Michele belongs to the early fifteenth century.

The stylistic relation between the works attributed to Zanino and the panels attributed to Michele requires extensive study and clarification. Still, the similarities between the panels attributed to Zanino in Torcello and our panels suggests that Michele might have been a follower of Zanino. Zanino was in Bologna from ca. 1389 to ca. 1406, or just before Michele's presumed earliest work. By 1407 Zanino was in Venice, and when Michele stayed there between ca. 1430 and 1437 he would have seen new examples of his supposed

master's work. If Michele was a follower of Zanino, the difference in their styles may be explained as follows: our panels could have been painted as late as twenty years after Zanino's iconostasis at Torcello (ca. 1420), during which period Michele would have responded to the flamboyant, International Gothic style of Gentile da Fabriano and his followers.

The New Testament locates both the Virgin and Saint John at the Crucifixion of Christ on Golgotha. According to the Gospel of Saint John (19:26–27), when Jesus "saw his mother, and the disciple [Saint John] standing by, whom he loved, he saith unto his mother, 'Woman behold thy son!', then saith he to the disciple, 'Behold thy mother!' And from that hour that disciple took her unto his own home." In a sense, Saint John takes the place of Christ in the Virgin's life, becoming a second son to her, and she becomes his mother.

The Virgin and Saint John almost always appear in scenes of, or related to, the Crucifixion of Christ, and they are often shown, as in our panels, lamenting his death—indeed, the Virgin in this context is sometimes called *Mater Dolorosa* (Sorrowful Mother). For that reason, and because the frame in which our panels are exhibited is not original, some scholars have suggested that they are fragments of a larger work. That supposed larger work might have been an altarpiece with a representation of the Crucifixion or one containing an *Imago Pietatis* (see Cat. No. 3) in its predella. In the latter instance, our panels would have flanked the figure of Christ, with the Virgin to his right and Saint John to his left.[4]

Evidence, however, suggests that the panels belonged to another type of painting.

4. For these suggestions regarding the original placement of the panels, see Shapley 1966, 73.

According to X-ray photographs, notched sections have been added to the four corners of each panel (Fig. 13), presumably to make each a conventional rectangular shape. In their original form, which would have been roughly a cross shape, each might have fitted into a quatrefoil frame like those usually found at the ends of the arms of a painted crucifix, like the one attributed to Michele in Bologna (Fig. 11).[5]

NORMAN E. LAND

5. Baumann in *Illustrated Museum Handbook*, 72.

Fig. **12.** *Zanino di Pietro*. Saint Bartholomew. *Tempera on wood. Iconostasis, Cathedral, Torcello.*
(Photo: Osvaldo Böhm)

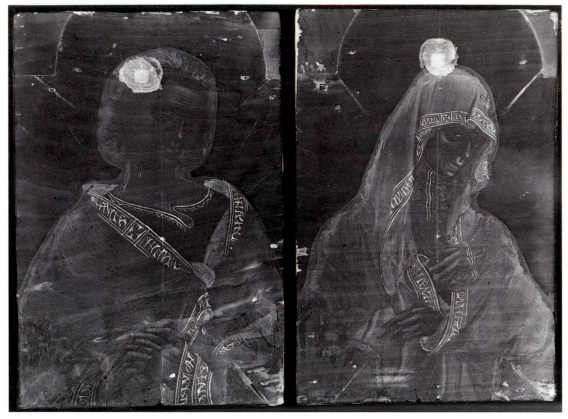

Fig. **13.** *X-ray photograph of Michele di Matteo,* Saint John the Evangelist. *Museum of Art and Archaeology, University of Missouri–Columbia.*

2 "Alunno di Benozzo" (Maestro Esiguo)

Florence: active late fifteenth century

Devotional Cross (ca. 1480–1490)

Tempera and gilt on wood panel. 52.7 × 41.6 cm. Museum of Art and Archaeology, University of Missouri–Columbia (61.73), Samuel H. Kress Collection (K 372).
Provenance: Graf Louis Paar (sold in Rome, March 20–28, 1889, no. 355 as Benozzo Gozzoli); Contini-Bonacossi Collection, Florence; Samuel H. Kress Collection (1935).
Literature: Shapley 1966, 117; Fredericksen and Zeri, 128; *Illustrated Museum Handbook*, 73.
Inscriptions: A Ω; INRI.

The anonymous artist responsible for this and other works was first identified by Roberto Longhi in 1927 as Maestro delle Figure Esigue (Master of the Small Figures), usually shortened to Maestro Esiguo, a name that is still used by some scholars. A few years later, Bernard Berenson independently identified the artist as "Alunno di Benozzo" (disciple or student of Benozzo), because of stylistic similarities between his work and that of the Florentine artist Benozzo Gozzoli (1420–1497).[1] The painting was once thought to be by Amadeo da Pistoia, but that attribution has not gained acceptance.[2]

This crucifix, the shape of which echoes the shape of the depicted, historical cross, contains four quatrefoils, one at the end of each arm. Where each quatrefoil meets an arm of the crucifix, there are relatively deep indentations lined with what might be lead. The function of these holes is not certain, but originally they may have held precious stones. In the top quatrefoil is the image of God the Father holding an open book that carries the Greek letters A (alpha) and Ω (omega), which refer to the Book of Revelation (22:13), where God says, "I am Alpha and Omega, the beginning and the end, the first and the last." In the left-hand and right-hand quatrefoils are the Virgin and Saint John, respectively (compare Cat. No. 1). Saint Catherine of Siena (1347–1380), a Dominican tertiary canonized in 1461, who wears the black-and-white habit of that order, appears in the bottom quatrefoil. She raises her arms in a gesture of prayer, displaying her stigmata, which echo the wounds in the image of Christ above her.

Above the crucified Christ, a pelican nests with her young in a blossoming bush or tree, which seems to grow out of the cross. This image is associated with the medieval belief that a pelican will feed its young with blood from its own breast, an activity that was understood to parallel Christ's sacrifice on the cross. We might recall, too, that on his way to be crucified Christ associated himself with the green tree: "For if they do these things in a green tree, what shall be done in the dry?" (Luke 23:31).

Below the pelican the *titulus*, bearing the letters INRI (Iesus Nazarenus Rex Iudaeorum, or Jesus King of the Jews), is nailed to the living tree. Below the tree and *titulus*, Christ hangs dead and bleeding from the cross, his head tilted toward the Virgin. His blood runs down the cross and over the small mound representing Golgotha. The skull at the foot of the cross refers to this location (Place of the Skulls) but also to Adam, who according to legend was buried in the very spot

1. For a discussion of the different names given to this master, see Bernard Berenson, *Homeless Paintings of the Renaissance*, 191–94. For further bibliography, see Shapley 1966, 117.

2. For this attribution, see Shapley 1966, 117.

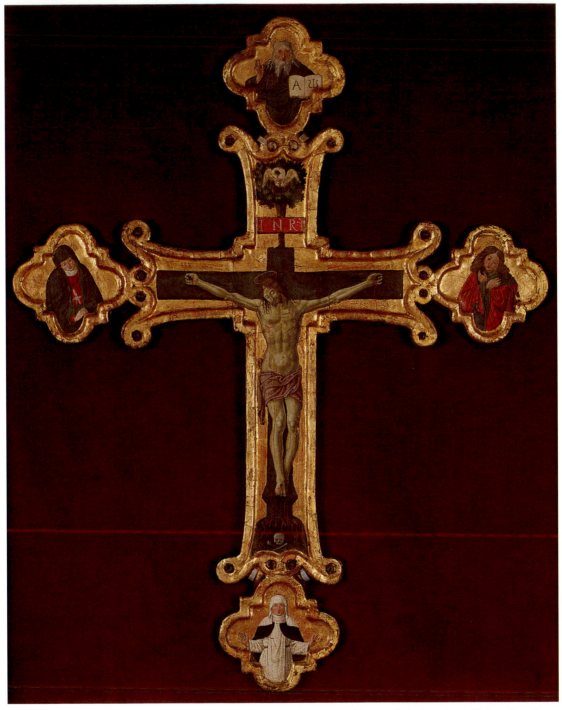

Cat. No. **2.** *"Alunno di Benozzo."* Devotional Cross. *Museum of Art and Archaeology, University of Missouri–Columbia; Gift of the Samuel H. Kress Foundation.*

Fig. **14.** *Attributed to Neri di Bicci.* Processional Cross (Dead Christ). *Tempera and gold on wood. Obverse. University of Michigan Museum of Art; Gift of the Baroness Maud Ledyard von Ketteler, 1942.6.*

Fig. **15.** *Attributed to Neri di Bicci.* Processional Cross (Living Christ). *Tempera and gold on wood. Reverse. University of Michigan Museum of Art; Gift of the Baroness Maud Ledyard von Ketteler, 1942.6.*

where Christ was crucified. Thus, for the Renaissance viewer, the blood would have been seen to wash away the sin of Adam and to be the means of Christ's triumph over death.

This crucifix is usually referred to as a "processional cross," and its size in relation to other paintings of the type, such as one attributed to Neri di Bicci in the Museum of Art, University of Michigan (Fig. 14), would suggest as much.[3] Processional crosses, however, are usually painted on both sides (see Figs. 14 and 15), and the reverse of our cross is not painted. This would suggest that our painting might have served as a devotional object, hung against a wall or other flat surface, perhaps in a church or a private dwelling.

The crucifix itself, and the figure of Saint Catherine in particular, suggests one way in which viewers might have experienced it in the Renaissance. Like Saint Francis, Catherine received stigmata as a sign of her Christ-like character. Significant for an understanding of our panel is the fact that in 1375, after receiving communion in the church of Santa Christina in Pisa, Catherine began to meditate upon a crucifix there.

Suddenly five blood-red rays shone from the crucifix, piercing her chest, hands, and feet and causing her great pain.[4] No one but Catherine was able to see the stigmata until after her death. The Renaissance viewer contemplating our crucifix would have recalled the stigmatization of Saint Catherine, who would have served as an exemplar not only of religious virtue but also of a particular, spiritual way of experiencing images.

Our crucifix, like many others of its kind, may be characterized as a timeless image that suggests history, or as an historical image that suggests the timeless. The presence of the Virgin and Saint John as well as the *titulus* indicates the historical event as narrated in the New Testament. On the other hand, Saint Catherine is a fourteenth-century saint, and the pelican is a timeless symbol. The cross, then, would have reminded the faithful viewer that although the Crucifixion took place in the distant past, its meaning and significance are eternal and valid for all times and places.

NORMAN E. LAND

3. For a discussion of Neri's *Crucifix* (55.5 × 46.9 cm), see Marvin J. Eisenberg, "A Processional Cross by Neri di Bicci."

4. For Giovanni di Paolo's predella panel illustrating the stigmatization of Saint Catherine, see Evelyn Welch, *Art and Society in Italy, 1350–1500*, fig. 66.

3 School of Verona

Madonna and Child and the Man of Sorrows (late fifteenth century)

Tempera on cloth. 33.8 × 22.1 cm. Museum of Art and Archaeology, University of Missouri–Columbia (61.75), Samuel H. Kress Collection (K 461).
Provenance: Aldo Noseda, Milan; Contini-Bonacossi Collection, Florence; Samuel H. Kress Collection (1936).
Literature: Shapley 1968, 11; Fredericksen and Zeri, 249; *Illustrated Museum Handbook*, 74.
Inscription: REGINA CELI

Our painting has been attributed to Domenico Morone (ca. 1442–ca. 1518) and to Girolamo dai Libri (1474/75–1555), both artists of Verona.[1] Morone was influenced by major northern Italian artists of the fifteenth century, including Antonio Pisanello, Jacopo and Giovanni Bellini, and Andrea Mantegna.[2] Girolamo dai Libri was a manuscript illuminator as a well as a panel painter. Although Vasari claims that Girolamo was active from the age of sixteen, his surviving paintings date to the early sixteenth century (for example, *Nativity with Rabbits,* Verona, Museo del Castelvecchio).[3] Like Morone, Girolamo was influenced by Mantegna and the Bellini. The attribution of our painting to Morone has been the more widely accepted and, given the strongly quattrocentesque qualities of the work, would seem to be correct. Still, until we know more about Morone and Girolamo dai Libri, the attribution to an anonymous artist of Verona seems the most appropriate.

1. For more about Domenico Morone, see *Dictionary of Art,* 22:130. For more about Girolamo dai Libri, see 19:322–23.
2. Shapley 1968, 11.
3. Vasari–de Vere, 2:45.

A horizontal band divides our painting into two tiers. In the lower and larger tier the Virgin and Christ child appear in a mountainous landscape in which are several leafy trees and other types of vegetation. As the Madonna of Humility, the Virgin sits on a pillow placed directly on the ground.[4] She grasps a small book in her left hand, and behind her a cloth of honor rises to touch the narrow band separating the two images. The Christ child holds a round object, perhaps a piece of fruit, in his right hand. In the top tier the mature Christ is presented as the *Imago Pietatis,* or Man of Sorrows.[5] His arms are crossed at the wrists in front of him as he stands in a sarcophagus composed of marble panels and classical molding. Blood from the crown of thorns runs down his forehead, and more blood gushes from the wound in his side. A cloth, perhaps the "linen clothes" (John 19:40) in which he was wrapped when placed in the tomb, lies over the front edge of the sarcophagus.[6] Behind Christ are instruments of his Passion, including the whips with which he was scourged, the cross on which he was crucified, two of the nails used to fix him to the cross, a sponge at the end of a pole that was used to give

4. For a still valuable discussion of the Madonna of Humility, see Millard Meiss, *Painting in Florence and Siena after the Black Death: The Arts, Religion, and Society in the Mid-Fourteenth Century,* 132–56.
5. For more about the *Imago Pietatis* (and for further bibliography), see Hans Belting, *The Image and Its Public in the Middle Ages: Form and Function of Early Paintings of the Passion,* 63–90, and Norman E. Land, "Two Panels by Michele Giambono and Some Observations on St. Francis and the Man of Sorrows in Fifteenth-Century Venetian Painting."
6. The cloth might be a representation of an altar cloth or corporal and if so, according to Belting, would signify "the equivalence between the sarcophagus and the eucharistic altar" (*The Image and Its Public,* 78).

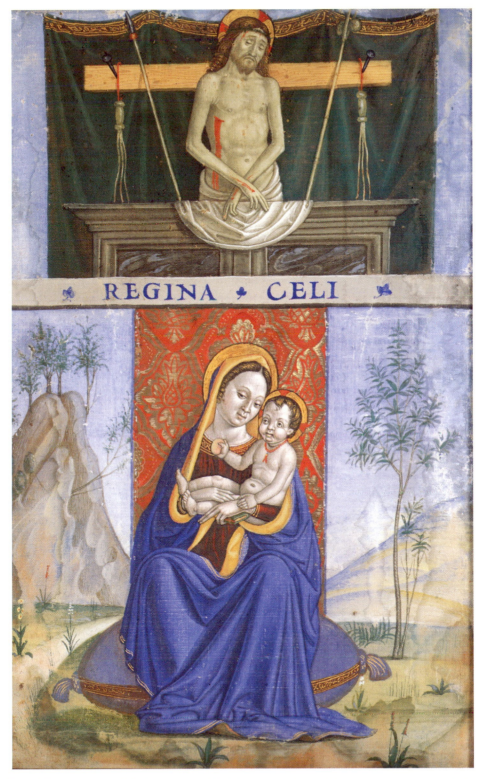

REGINA ♦ CELI

Cat. No. **3.** *School of Verona*. Madonna and Child and the Man of Sorrows. *Museum of Art and Archaeology, University of Missouri–Columbia; Gift of the Samuel H. Kress Foundation.*

him drink, and the lance that was used to spear his side.

The unusual placement of the two images, one over the other, and the fact that they are painted on a finely woven cloth suggest that our painting may once have been used as a portable standard (*stendardo*) or banner. That is to say, the cloth may have been attached to a pole and carried aloft during a religious procession, such as those made during Holy Week.[7] A much larger example of such a banner is at the center of the bridge in Gentile Bellini's *Miracle of the True Cross* of 1496 in the Gallerie dell'Accademia, Venice. In our painting, the colors are rich and bright, and the modeling of both anatomy and drapery is clear and strong, suggesting that, although the work is quite small, the composition easily could have been seen and understood from afar.

Still, the complexity of the two images and their relation to one another suggest that this work, in addition to its function as a processional standard, might also have served as a devotional object. Certainly the painting's subject matter invites meditation.[8] For example, as we have already mentioned, we see Christ both as infant and as crucified adult. This simultaneous presentation of these two images is especially important if the object that the Christ child holds is a piece of fruit, which surely would have reminded the Renaissance viewer of the Garden of Eden and the disobedience of Adam and Eve. Moreover, Christ and the Virgin, who were sometimes identified as the new Adam and the new Eve, appear in a beautiful and serene landscape, a new Eden, one that is redeemed of sin. In that instance, the tree to the right of the figures would have reminded the viewer of another of the trees in Eden, the Tree of Life.

The Latin inscription, *REGINA CELI*, which refers to the Virgin as the queen of Heaven, invites further meditation. Normally, when she is represented in that role, she appears seated in majesty on a throne and wearing a crown. Our painting, then, suggests a contrast, or perhaps harmony, between the Virgin's exaltation as queen of Heaven and her humility.[9] A similar contrast, or harmony, is suggested by the images of Christ, one person of the trinitarian Godhead who suffered the humiliation of crucifixion to become the Man of Sorrows.

MARJORIE OCH AND NORMAN E. LAND

7. Baumann in *Illustrated Museum Handbook*, 74.

8. Meiss points out that the images of both the Madonna of Humility and the *Imago Pietatis* are devotional in character and "establish a direct, sympathetic, and intimate emotional relationship between the spectator and the sacred figures" (*Painting in Florence and Siena*, 145).

9. Meiss discusses the contrast between the two aspects of the Virgin: "The Virgin is *Regina coeli* and *Nostra domina de humilitate*, and thus '*Regina humilitatis*' " (ibid., 153–54).

4 Bernardino Fungai

Siena: 1460–1516

A Saint-King (ca. 1490)

Tempera and gilt on wood panel. 123.8 ×
 47 cm. Museum of Art and Archaeol-
 ogy, University of Missouri–Columbia
 (61.74), Samuel H. Kress Collection
 (K 378).
Provenance: Contini-Bonacossi Collection,
 Florence; Samuel H. Kress Collection
 (1935).
Literature: Shapley 1968, 109; Fredericksen
 and Zeri, 76.

A youthful saint-king, with orb and
scepter and gilt halo and crown, stands
on a shallow stone ledge before a royal blue
background. His patterned, gold brocade
robe (*vestito*), lined and trimmed at the
neck and hem and belted at the waist by
a knotted cloth sash, falls in heavy folds to
his stockinged ankles. A large and richly
bejeweled pendant hangs by a thin cord
from around his neck, along with a broad
gold-embossed and jewel-encrusted collar
pendant.[1] In his hands he holds the signs of
royal office: the orb, signifying sovereignty
over the world, and the scepter, one of the
oldest insignia of royalty. The thin glass
rod of the king's scepter is topped by a
gold fleur-de-lis ornament. The gold and
bejeweled crown with elaborate fleur-de-lis
decoration is another sign of his earthly
kingdom, just as the gold-embossed halo
affirms his sanctity and status as a saint-king.

1. For recent discussions of costume and
its significance, see Elizabeth Birbari, *Dress in
Italian Painting, 1460–1500;* Jacqueline Herald,
Renaissance Dress in Italy, 1400–1500; and Stella
Mary Newton, *The Dress of the Venetians, 1495–1525.*
See also Anne Hollander, *Seeing through Clothes.*

The king's long, curling brown hair falls
in soft abundance to his small, sloping
shoulders. His hair frames an elongated
face with delicate features: a long nose,
pursed lips, a narrow chin, and round eyes
surmounted by high, thin brows. His hands
are equally dainty, even slightly effeminate,
as is the entire demeanor of this young
monarch.

The round-headed panel, approxi-
mately four feet tall, evidently once formed
part of a polyptych, a multipanel altarpiece.
The slight leftward turn of the body and
head indicates that the saint-king most likely
stood to the right of a central panel, possibly
in company with other standing saints of
similar dimensions.

Who is this gentle, elegantly dressed
sovereign? The youthful demeanor com-
bined with the imperial regalia immediately
suggests Saint Louis of France.[2] Born at
Poissy in 1214, Louis IX became king of
France at the tender age of twelve. Alter-
natively, the panel might represent Saint
Sigismund, king of Burgundy, who was
converted to Christianity shortly after he
came to the throne in 516.[3] Like Louis,
Sigismund is most often represented as a
king, sometimes as youthful and sometimes,
more sagely, as bearded and middle aged.
Although both Louis and Sigismund are
"foreign" saints, originally from France
and Burgundy respectively, both are also
found in Italian Renaissance painting. Saint

2. On Saint Louis, see Jean de Joinville, *Histoire
de S. Loys IX du nom, roy de France;* Louis Réau,
Iconographie de l'art chrétien, 2:815–20; and Anna
Jameson, *Legends of the Monastic Orders,* 319–25.

3. On Saint Sigismund, see Réau, *Iconographie,*
3:1214–16, and Jameson, *Monastic Orders,* 173–74.
We should notice, too, a King Sigismund (1368–
1437) who ruled Hungary and Bohemia and was
popular in Italy following the prominent role he
played at the Council of Constance (1414–1418).
Our panel, however, dates considerably later than
that event.

Cat. No. **4.** *Bernardino Fungai*. A Saint-King *(before conservation treatment). Museum of Art and Archaeology, University of Missouri–Columbia; Gift of the Samuel H. Kress Foundation.*

Louis's popularity spread throughout Italy with the expansion of Angevin influence in the thirteenth century. The cult of Saint Sigismund was popular in Burgundy and Bavaria, from which it spread into northern Italy. The duke of Milan, Francesco Sforza, consecrated a church to Sigismund in Cremona, where Louis is a patron saint, and the ruler of Rimini, Sigismundo Malatesta, favored his namesake in commissioning Piero della Francesca to paint a fresco of Saint Sigismund in the Tempio Malatestiano.

Saint Louis is more common than Sigismund in Tuscan painting, largely because of the widespread popularity of the saint and his many legends and because of the ubiquity of French influence in Tuscan affairs. The artist's emphasis on the king's youth and pious innocence, and especially the distinctively French fleur-de-lis decoration, all favor recognizing this as Saint Louis.[4] Thus the spiky character of the king's crown and the leaf ornamentation on his robe might prompt a viewer to recall the famous relics of the Passion for which Louis built the Sainte-Chapelle in Paris. Moreover, the altarpiece is approximately contemporaneous with another King Louis, Louis XII of France (ruled 1498–1515), who exercised control and widespread influence in Italy following the first French invasion in 1494. Our saint's identity, however, cannot be established with complete certainty.

Cristoforo di Niccolò d'Antonio di Pietro, generally known as Bernardino Fungai, was an eclectic painter of the Umbrian-Sienese school and was an accomplished, if limited, master.[5] Perhaps his best-known work is a signed and dated (1512) altarpiece (Fig. 16) painted for the church of San Niccolò al Carmine in Siena. Our panel offers good evidence of the artist's gracile style, a combination of engaging naïveté and technical facility. The emphasis on the variety and richness of patterns and texture, creating a tension between surface ornamentation and three-dimensional representation, is entirely typical of Fungai's Sienese origins.

More attractive than sublime, more comely than kingly, our figure is perfectly characteristic of late Sienese painting. Without the other parts of the altarpiece and more precise historical information regarding its provenance, our panel remains an example of what Bernard Berenson aptly called a "homeless painting of the Renaissance."

WILLIAM E. WALLACE

4. Similar attributes adorn Philippe de Champaigne's *Vincent Voiture as Saint Louis* in the Saint Louis Art Museum (inv. 719:1961).

5. For more about Fungai, see *Dictionary of Art,* 11:842.

Fig. **16.** *Bernardino Fungai.* Madonna and Child Enthroned with Saints Sebastian, Jerome, Nicholas, and Anthony of Padua. *Tempera on wood. Pinacoteca Nazionale, Siena. (Photo: Art Resource)*

5 Attributed to Giovanni Francesco de' Manieri

Parma: doc. 1489–1506

Ex Voto (dated 1501)

Oil on wood panel. 28.6 × 32.4 cm. Museum of Art and Archaeology, University of Missouri–Columbia (61.80), Samuel H. Kress Collection (K 1182).

Provenance: Private Collection, Ferrara; Contini-Bonacossi Collection, Florence; Samuel H. Kress Collection (1939).

Literature: Shapley 1968, 67; Fredericksen and Zeri, 117; Silla Zamboni, *Pittori di Ercole I d'Este*, 15, 19–20, 44, and colorplate VIII; Peter Thornton, *The Renaissance Interior, 1400–1600*, 88, fig. 89; Joseph Manca, *The Art of Ercole de' Roberti*, 63 n. 206 and fig. 30.

Inscription: A[nno] S[alutis] / MDI / Erravi fateor Par[c]as mi h[odi]erna precantem / Sol[o] det genitrix Virgo sopitus af[a]m[e]n / Ehiu planctu lacrimis gemitu precibus [que] superba / Hactenus in [ri]pam Nimpha pr[e]cata mihi est / Fatebar novi: dubio nam principe vite / Febre: semel suplex me ad tua vota tuli / Protinus auditis precibus pia Virgo: dedisti / Incolumem qui iam semisepultus erat / Quare age deducerit mea donec stamina Parce / Relliquiasque mei pulueris uma reget / Tu requies tranquilla mihi tu portus et aura / Principium medium semita finis eris.[1]

Giovanni Francesco de' Manieri seems to have been born in Parma, probably in the 1460s, the son of a painter, Pietro de' Manieri.[2] He is first documented in Ferrara, however, and his style reveals his debt to the works of his master, Ercole de' Roberti. Manieri divided his career as a painter and miniaturist between Ferrara, where he worked for Ercole I d'Este and Eleonora of Aragon, and Mantua, where, among other works, he painted a now lost portrait of Isabella d'Este. Perhaps his best-known painting is the *Madonna and Child with Saints William and John the Baptist,* the so-called Pala Strozzi, in the National Gallery, London (Fig. 17), of 1489, which was completed by Lorenzo Costa (1460–1535).

Since ancient times devout persons occasionally offered gifts, or thank-offerings, to a deity for deliverance from a misfortune. The practice was adopted by Christians, who offered gifts—often works of art, such as paintings or sculpture—to Christ, the Virgin, or a particular saint. According to the Renaissance art historian and critic Giorgio Vasari, these votive works, which varied in size and quality, were referred to as "miracoli" and were usually placed in churches or chapels; wealthy Florentines, for example, favored the church of Santissima Annunziata and Orsanmichele.[3] These works are also sometimes referred to as *ex voto* (literally, "from a vow"), because they were often related to a vow made in the face of a calamity.[4] A facetious example of such a vow is given by Francesco Sacchetti in his *Trecento novelle* (CIX), where he tells of a man who lost a cat and vowed to send a wax figure of it in gratitude to the image

1. The transcription is by Robert P. Sonkowsky in Shapley 1968, 68.

2. For more on Manieri and his works, see Silla Zamboni, *Pittori di Ercole I d'Este*, 15, 19–20, 44.

3. Vasari–de Vere, 1:556.

4. For the history and function of *ex voto* images, see David Freedberg, *The Power of Images: Studies in the History and Theory of Response*, 136–60, 225–31, 235–37.

Cat. No. **5.** *Attributed to Giovanni Francesco de' Manieri.* Ex Voto. *Museum of Art and Archaeology, University of Missouri–Columbia; Gift of the Samuel H. Kress Foundation.*

of the Virgin in Orsanmichele if the animal was found.

In Manieri's votive panel we see an old man lying ill in a bed. In front of the bed, as if in a vision, two infant angels, one completely naked and the other wearing a green shirt or mantle, hold up a tablet inscribed with a prayer. To the left of the sleeping man is a small, red, semicircular shelf on which rests a diptych, in each panel of which seems to be a half-length figure. To the right of the inscribed tablet a young man, a friend or relative of the old man (perhaps his son),

kneels on the chest that runs along the side of the bed. He seems to be praying for the recovery of the sleeping man. Behind him, another man, possibly a servant, carries a large plate in his left hand and an ewer in his right as he exits the room through an open doorway. The servant's departure with such valuable goods might signal his expectation that the old man does not have long to live.

Although somewhat obscure in its meaning, the inscription on the tablet held by the angels is the key to understanding the scene.

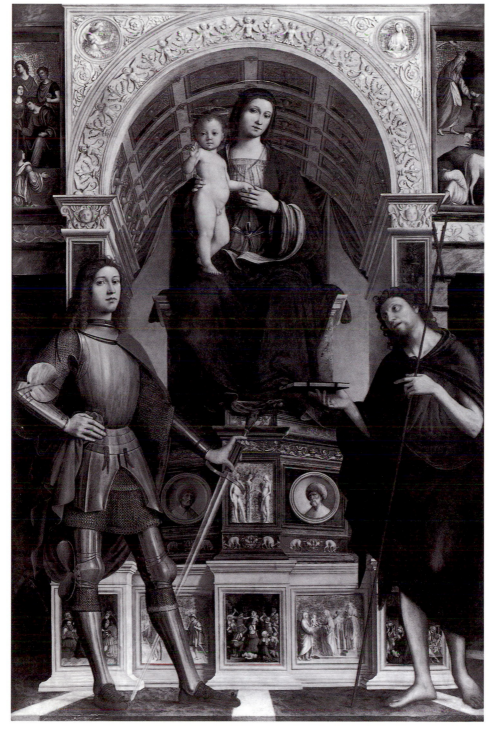

Fig. **17.** *Giovanni Francesco de' Manieri and Lorenzo Costa.* Madonna and Child Enthroned with Saints William (of Aquitaine?) and John the Baptist. *The Pala Strozzi. Tempera on wood. London, National Gallery. (Photo: National Gallery of Art, London)*

I have sinned, I confess. Have mercy on
me. Let the Virgin Mother only grant the
approach of sleep to me as I pray for daily
things. Up to this point, on the shore,
the proud Nymph, with oh lamentation,
tears, groaning, and prayers, was prayed
to by me. I confessed, I acknowledge: for
when the foundation of my life wavered
with fever, as soon I came as a suppliant
in prayer to Thee, hearing my prayers at
once thou hast granted, Holy Virgin, safety
to one who had already been half buried.
Therefore, then, until the funeral urn spins
out my threads of Destiny and rules over
the remains of my dust, Thou shalt be
my peaceful rest, my harbor and breeze,
the beginning, the middle, the pathway,
the end.[5]

This is the prayer of a sinner who formerly
prayed to the "Nymph on the shore"
(perhaps an allusion to Venus, who was
born from the sea), but now has sought the
aid of the Virgin Mary. This sinner recalls
a time when a fever threatened his life and
he had one foot in the grave but the Virgin
mercifully granted him safety. Now, until

the funeral urn contains his ashes, he has
devoted his life to her. In short, the prayer
is both a recollection of a near-fatal illness
and a vow to follow the Virgin's straight-and-
narrow path.

One scholar has suggested that the panel
"commemorates a vow offered up to the
Virgin in supplication for the recovery of
the old man in the bed."[6] But who, we may
ask, offers up the prayer; who makes the
vow? Surely not the man in the bed, who
is unconscious, nor the kneeling man, who
has no need to offer that prayer, for he is
well. Probably the inscription records the
prayer said by the person who ordered the
panel. That is to say, the old man, after he
had recovered from his illness, ordered this
panel to commemorate his recovery. In this
case, the panel would have functioned not
only as a representation of his brush with
death but also as a perpetual prayer to the
Virgin and as a thank-offering to her for
saving his life.

NORMAN E. LAND

5. Translation by Sonkowsky in Shapley 1968,
68.

6. Shapley 1968, 68.

6 Bartolommeo Montagna

Vicenza: 1453/54–1523

Temptation of Saint Anthony (ca. 1510)

Oil on panel. 24.3 × 34.8 cm. Museum of Art and Archaeology, University of Missouri–Columbia (61.84), Samuel H. Kress Collection (K 1638).
Provenance: Paul Bottenweiser Collection, Berlin; Ludwig Furst Collection, New York (1949); Samuel H. Kress Collection (1949).
Literature: Shapley 1968, 57–58; Fredericksen and Zeri, 143.

Dressed in a monk's habit and cowl, the balding, long-bearded Saint Anthony is seated on a rocky perch outside his wilderness cell. The book he has been reading is propped open on his lap, but his meditations have been interrupted. He glances up and to his left with a faraway look that is at once peaceful and melancholic. Unwittingly, Anthony has been tempted, just as we are when looking at this charming yet poignant little picture. Entering along the pathway from the left is a comely young woman who disrupts Anthony's meditative tranquillity, the intimate space of the foreground, and the compositional balance of the picture.

The gracile woman does not belong in the wilderness. She is adorned according to her apparently aristocratic station. Her fashionable red dress is gathered at the waist by a dark blue beltlike sash accentuating the tight, square-cut bodice. She sports separate dark blue full-length sleeves from which dangle numerous ties, or *stringhe,* that are a sign of high fashion. A thin line of white chemise is visible underneath the bodice, and it billows in ornamental puffs at the

shoulder armrolls and the slashed elbow and wrist. Her chestnut-brown hair is pulled back from her face and falls in long tresses down her back. The bun, of slightly reddish color, is a separate hairpiece partly held in place by the openwork cloth fillet that encircles her head.[1]

We are easily seduced by the young woman's beauty, by the dignity of her carriage, and by the disarming gesture of greeting that she proffers. Yet not all is well in this seemingly innocent encounter, as Anthony already is aware and we will soon discover, for the gentle maiden is none other than the Devil in the guise of Temptation. Her true character is revealed in the suggestive hitch of her dress, in itself an immodest gesture, as an aristocratic woman never exposed her feet, especially if they were of ungainly size, unshod, and ended in claws! She is lust; she is *luxuria;* she is the Devil incarnate, whose temptation is all the more beguiling for its seeming innocence.

How different this scene is from the usual depiction of the temptation of Saint Anthony. Anthony was a hermit saint who sought refuge in an asceticism pursued far from worldly temptation. Living a life of extreme self-denial, he nonetheless was subject to vivid hallucinations and satanic visions. In nearly contemporaneous representations of the subject by Martin Schongauer, Hieronymus Bosch, and Matthias Grünwald, for example, Anthony suffers physical torment, assaulted by legions of evil fiends, erotic visions, and strange apparitions.[2] Here, instead of

1. For discussions of Renaissance dress, see Cat. No. 4, n. 1, above.
2. For more on the iconography of Saint Anthony, see Anna Jameson, *Sacred and Legendary Art,* 2:723–38, and Charles D. Cuttler, "The Temptation of Saint Anthony in Art from Earliest Times to the First Quarter of the Sixteenth Century."

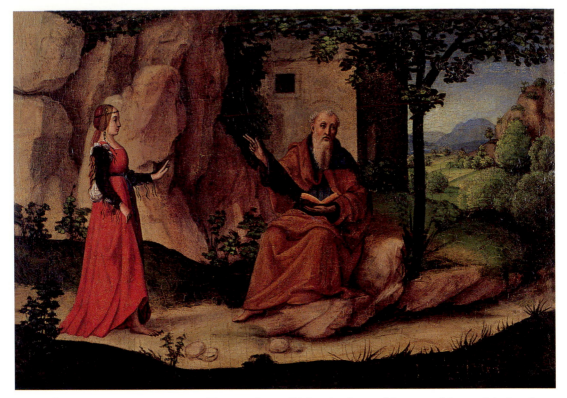

Cat. No. **6.** *Bartolommeo Montagna*. Temptation of Saint Anthony. *Museum of Art and Archaeology, University of Missouri–Columbia; Gift of the Samuel H. Kress Foundation.*

the usual wrestling match between saint and demons, the battle is waged within Anthony himself. By presenting the episode in such an understated, even laconic, fashion, the artist also cleverly tempts the viewer. In perusing the scene and its many interesting details, we as spectators are inevitably drawn into Temptation's web, sinning through indulgent looking. We are less successful than Anthony in avoiding her wiles, but since we already have succumbed, let us admire some of the means by which the artist effectively constructs his narrative.

The underlying tension of the scene is conveyed through a "collision" of gestures and glances. The gestures of the two protagonists are in studied contrast, a contrast that is reinforced by the rock formations that enframe and, in a sense,

extend those gestures. The true character of Temptation's seemingly innocent greeting is betrayed by the cracking of the barren rock around her hand. Similarly, her clawlike toes find a natural counterpart in the close proximity of the spiky weed that thrusts itself into the smooth path. In contrast, Anthony's more forceful arm movement, a rising diagonal reiterated by the rock behind, is surrounded by verdant green. This is not a gesture of refusal or denial but rather one that suggests blessing, since the true measure of Anthony's willpower and sanctity is revealed in his ability to forgive rather than condemn. Not accidentally, large dark fissures rend the cliff face between the two figures, as though nature were providing a counterpoint to the human confrontation taking place.

Fig. **18.** *Bartolommeo Montagna.* Saint Mary Magdalen and Four Saints. *Tempera on wood. Chiesa di Santa Corona, Vicenza. (Photo: Art Resource)*

Anthony's leaf-framed gesture, his kindly visage, and the yellowish orange book against his blue tunic form a triangle of color accents at the center of the composition, while Temptation remains at the left margin, shunned. The foliage that frames Anthony and his cell is painted with impasto accents. Prompted by the slight turn of Anthony's body and the direction of his glance, we are encouraged to follow the path beyond the prominent tree and into the distant landscape at the right side of the picture. While this could be seen as merely a lovely, fertile landscape in the pastoral mode of North Italian, including Venetian, painting,[3] it is also the untainted nature where Anthony sought spiritual refuge. Even in the limited space of this tiny panel, in reading from left to right we effect a physical and spiritual journey, from an inhospitable, barren nature to a verdant idyllic landscape, from temptation to salvation.

Bartolommeo Cincani, who was called Bartolommeo Montagna, is generally acknowledged to have been the founder of the school of Vicenza at the end of the fifteenth century.[4] In 1469 he is documented in Venice, where he probably trained, perhaps with Alvise Vivarini. His early work also shows the influence of Antonello da Messina and Giovanni Bellini. In 1478 he was mentioned in Vicenza as an "egregio maestro," with a reputation sufficient to earn him the commission for two large canvases for the Scuola Grande di San Marco in Venice. He executed a number of important commissions in Verona, Padua (Scuola del Santo), and Vicenza. Our panel might have formed part of the predella for a now lost altarpiece of 1517, the *Madonna Enthroned with Christ Child, and Saints,* for the church of Breganze, a village close to Vicenza, which altarpiece probably would have been close in style to the *Saint Mary Magdalen and Four Saints* (Fig. 18) in the church of Santa Corona, Vicenza.[5]

Montagna, then, is an artist with a Venetian pedigree and one who garnered a number of important commissions. While he is less familiar today, we need look no further than this little panel to find the painterly abilities and poetic sensibility that link him to his more famous compatriots. At the same time, the panel finds its properly modest place in history when we consider that in 1517 Titian completed the *Assunta* for the high altar of Santa Maria Gloriosa dei Frari in Venice. Montagna's *Temptation of Saint Anthony* is a poetic moment in the midst of more heroic accomplishments.

WILLIAM E. WALLACE

3. For more on this subject, see Robert C. Cafritz, Lawrence Gowing, and David Rosand, *Places of Delight: The Pastoral Landscape,* and John Dixon Hunt, ed., *The Pastoral Landscape.*

4. For a convenient discussion of Montagna and for further bibliography, see *Dictionary of Art,* 21:904–6.

5. Tancred Borenius, "Saint Anthony and the Centaur in Two Predella Pictures by Bartolomeo Montagna," associated our panel with another predella panel, of only slightly different dimensions, formerly in the collection of Count Lanckoronski of Vienna. See also Lionello Puppi, "Un'integrazione al catalogo e al regesto di Bartolomeo Montagna," 26–27.

7 Attributed to Girolamo di Romano, called Romanino

Brescia: ca. 1485–ca. 1560

Christ Blessing (Salvator Mundi)
(ca. 1510–1520)

Oil and gilt on wood. 55 × 40.6 cm. Museum of Art and Archaeology, University of Missouri–Columbia (61.76), Samuel H. Kress Collection (K 1033).
Provenance: Contini-Bonacossi Collection, Florence; Samuel H. Kress Collection (1936).
Literature: Shapley 1968, 86; Fredericksen and Zeri, 176; Norman E. Land, "Romanino and the 'Shadows of Death.' "

Girolamo di Romano, called Romanino, was born in Brescia between 1484 and 1487 and died between 1559 and 1561. He carried out major works in cities other than his birthplace, including Padua, Venice, and Cremona. Perhaps his best-known work is the series of frescoes (1519–1520) illustrating four scenes from the Passion of Christ in the Duomo at Cremona, where Altobello Melone (see Cat. No. 8) had also worked. Romanino's style is a synthesis of elements from the art of Lombardy and that of Venice, including the works of Giovanni Bellini, Giorgione, and Titian.[1]

The paintings of many Renaissance artists reveal an interest in light and the representation of light, and, as is well known, this interest was a major factor in the general pursuit of an ever more naturalistic style. Many of the same artists also used light as symbol, most often of a divine presence such as angels, visions, and even God himself.[2] Less noticed is the artist's awareness of the natural phenomenon often accompanying light—shadow.[3] Evidence of this awareness can be found in, for example, Leonardo da Vinci's notebooks, where the master of *sfumato* made a number of scientific observations on the properties of shadow, including this one: "The imprint of the shadow of any body of uniform thickness will never be similar to the body from which it is born."[4] Moreover, just as light could have symbolic meaning, so could shadow.

As the shadow cast under Christ's nose suggests, the light in Romanino's panel radiates from the upper-left-hand corner. This is a natural-looking light that illuminates the figure, the background, the parapet, and the orb much as sunlight might. We cannot be certain, however, that this is sunlight because the place in which Christ stands cannot be specifically identified. The light, then, might emanate from a divine source, perhaps from Heaven or from God.

Like the works of other artists of the Renaissance, Romanino's panel implies that the source of its light is behind and to the left of the viewer standing in front of the picture. This imaginary light source enhances the viewer's sense of participation in the painting. The viewer is not a detached spectator, for his or her space has been transformed: "there is a dissociation from the ambient lighting and hence a . . .

2. For the use of light as symbol, see Millard Meiss's still valuable "Light as Form and Symbol in Some Fifteenth-Century Paintings."

3. Two recent publications concerning shadows are Ernst Hans Gombrich, *Shadows: The Depiction of Cast Shadows in Western Art,* and Michael Baxandall, *Shadows and Enlightenment.*

4. "La stampa dell'ombra di qualunque corpo di uniforme grossezza mai sarà simile al corpo donde ella nasce" (*The Literary Works of Leonardo da Vinci,* 1:194).

1. For a discussion of Romanino's style, see Sydney J. Freedberg, *Painting in Italy, 1500 to 1600,* 360–67. See also *Dictionary of Art,* 26:726–28.

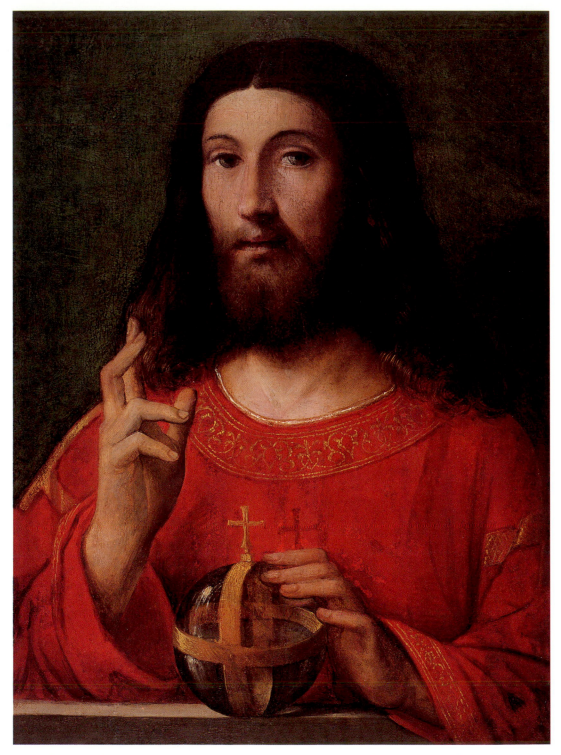

Cat. No. **7.** *Attributed to Girolamo di Romano, called Romanino*. Christ Blessing (Salvator Mundi).
*Museum of Art and Archaeology, University of Missouri–Columbia; Gift of the Samuel H. Kress
Foundation.*

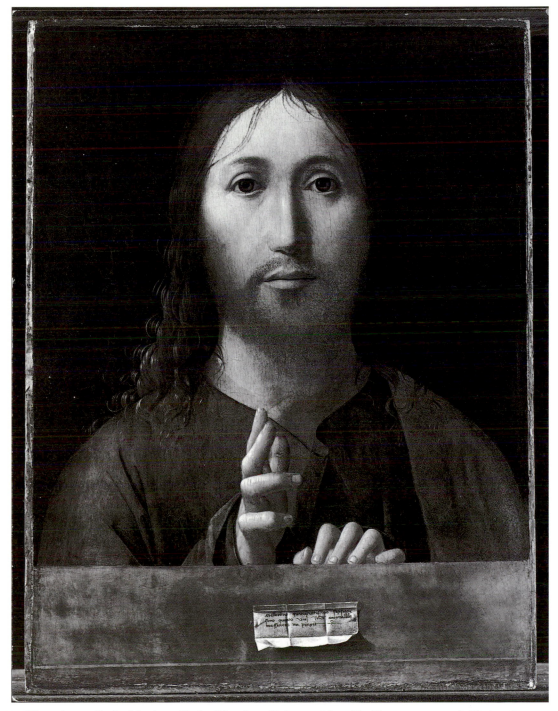

Fig. **19.** *Antonello da Messina*. Christ Blessing (Salvator Mundi). *Tempera on wood. National Gallery, London. (Photo: National Gallery of Art, London)*

refiguration of a beholder's space."[5] The viewer may literally stand in the everyday space of a museum, but he or she is physically and emotionally implicated in the virtual space of the painting and in its meaning. Even the Renaissance viewer, who probably would have seen the painting in a domestic setting, would have experienced it in much the same way.

Three projections of light (the gold leaf is badly rubbed and only traces of it are visible) shining from the top and sides of Christ's head function as a kind of halo and suggest an aura. They represent a modernized version of the traditional three clusters of gold rays that frequently compose conventional cruciform halos worn by both the infant and adult Christ in countless earlier paintings. Furthermore, these bits of light remind us of the traditional association of Christ and light. In the opening of the Gospel According to John (1:3–9), for example, the author speaks of "the light [that] shineth in darkness" and refers to Christ as "the true Light, which lighteth every man that cometh into the world."

At first glance, Romanino's panel seems iconographically conventional. The composition is related to such earlier works as a *Salvator Mundi* by Antonello da Messina in the National Gallery of Art, London (Fig. 19), in which a half-length Christ stands behind a parapet and blesses the viewer. Unlike Antonello's figure, however, Romanino's bearded Christ holds a crystal orb, divided into quadrants by two gold bands and surmounted by a small gold cross, symbolizing the Christian universe and his

triumphant and benevolent rule over it. There is also a tiny detail, easily overlooked, that is not found in Antonello's panel, one that deepens the meaning of Romanino's painting and enriches our experience of it. The cross on the orb casts a shadow on the gold-trimmed bright-red tunic of Christ, which almost vibrates against the green ground surrounding the figure. If this shadow were consistent with the source and direction of the light in the rest of the painting, it would not be as large as it is. We must assume that the artist intentionally sacrificed consistent naturalism in order to give this shadow such prominence.

This detail—the shadow of the cross— is a reminder to the receptive viewer of the means by which Christ's triumph was achieved. Romanino poetically associates death and shadow, for the shadow is in the shape of the instrument of Christ's death. Given this association, a devout viewer might have recalled the words in Psalm 22 (Vulgate) of David, who was an ancestor of Christ: "et si ambulavero in medio umbrae mortis non timebo mala" ("And if I walk amidst the shadows of death, I will fear not evil"). The worshiper would remember that Christ's body was crucified and, by extension, that he died, was buried, and rose from the dead. Just as we all must, the Light of the World "walked among the shadows of death." Thus, the triumphant golden cross on the orb and its cross-shaped shadow are poetically linked to the actual wooden cross of the Crucifixion, and Romanino's timeless image of radiant triumph and blessing is connected to a dark, excruciating moment in history.

5. Schwartz, "Beholding and Its Displacements," 236. In this stimulating article, Schwartz discusses the light and its implication for the beholder in Fra Filippo Lippi's *Madonna and Child* in the Palazzo Medici-Riccardi, Florence (235–36).

NORMAN E. LAND

8 Altobello Melone

Cremona: ca. 1490–ca. 1543

Madonna and Child Enthroned (ca. 1520)

Oil on wood transferred to Masonite.
 111.8 × 47.6 cm. Museum of Art and
 Archaeology, University of Missouri–
 Columbia (61.77), Samuel H. Kress
 Collection (K 1097).
Provenance: Church of Sant'Elena, Cre-
 mona (?); Galleria delle Torre dei
 Picenardi, Cremona (before 1869);
 Anonymous English dealer (1872);
 Contini-Bonacossi Collection, Flo-
 rence; Samuel H. Kress Collection
 (1937).
Literature: Shapley 1968, 86; Fredericksen
 and Zeri, 140; Christopher Lloyd, *A
 Catalogue of the Earlier Italian Paintings in
 the Ashmolean Museum*, 114–15; *Illustrated
 Museum Handbook*, 75; Mina Gregori,
 ed., *I Campi e la cultura cremonese del
 Cinquecento*, 97; Mina Gregori, ed.,
 *Pittura a Cremona dal Romanico al
 Settecento*, 260; Sydney J. Freedberg,
 Painting in Italy, 1500–1600, 375;
 Dictionary of Art, 21:94.

According to a sixteenth-century source,
Marcantonio Michiel, Altobello Melone was
"a clever young man with considerable
talent for painting." Michiel also reports
that the painter was a pupil of Girolamo di
Romano, better known as Romanino (see
Cat. No. 7), to whom our panel was once
attributed.[1] In December 1516, Altobello
was commissioned for a series of frescoes in
the nave of the cathedral at Cremona, a cycle
that had been begun in 1508 by an older

painter, Boccaccio Boccaccino, and, after
Altobello, was continued by Gianfrancesco
Bembo. Altobello's style is indebted not
only to Romanino but also to such northern
artists as Altdorfer and Dürer, as well as to
Venetian artists, especially Lorenzo Lotto,
Giorgione, Titian, and the much less famous
Marco Marziale, who lived in Cremona from
1500 to 1507.[2]

Our *Madonna and Child Enthroned* of
ca. 1520 is probably one of three panels
that composed the so-called Picenardi
triptych, seen in the nineteenth century
by Federico Sacchi and described as follows:
"The Virgin and Child enthroned in the
middle, Saint Helen and Tobias and the
Angel on the sides. Triptych in oil on wood;
1 m. 12 cm high and 1 m 42 cm. wide.
This painting, coming from the Gallery
of the Torre dei Picenardi, was sold to
an English antiquarian in 1869."[3] The
lateral panels seen by Sacchi are almost
certainly *Saint Helen with the Cross* (Fig.
20) and *Tobias and the Angel* (Fig. 21),
both now in the Ashmolean Museum,
Oxford.[4]

1. [Michiel, Marcantonio], *The Anonimo: Notes
on Pictures and Works of Art in Italy made by an
Anonymous Writer of the Sixteenth Century*, 50.

2. For more information about Altobello and
for further bibliography, see *Dictionary of Art*,
21:93–94.
3. Federico Sacchi, *Notizie pittoriche cremonesi*,
134: "La Vergine ed il Bambino in trono, nel mezzo,
S. Elena e Tobia coll'Angelo, ai lati. Trittico dipinto
in tavola ad olio; alto un metro e 12 centim., largo
un metro e 42 centim. Questo dipinto, proveniente
dalla Galleria delle Torri de' Picenardi, fu nel 1869
venduto ad un antiquario Inglese" (134). Sacchi
saw the triptych when it was in the possession of
the Milanese antiquarian Baslini, who had had the
collection since 1869.
4. Luigi Grassi, "Ingegno di Altobello Melone,"
citing the aid of Luigi Salerno and Roberto Longhi,
was the first to associate our panel and the Oxford
panels with Sacchi's description and hence with the
Picenardi triptych. He says that the Oxford panels
came from Cremona in 1869. See also Christopher
Lloyd, *A Catalogue of the Earlier Italian Paintings in
the Ashmolean Museum*, 113–15.

Cat. No. **8.** *Altobello Melone*. Madonna and Child Enthroned. *Museum of Art and Archaeology, University of Missouri–Columbia; Gift of the Samuel H. Kress Foundation.*

Fig. **20.** *Altobello Melone.* Saint Helen with the Cross. *Tempera on wood. Ashmolean Museum, Oxford. (Photo: Ashmolean Museum, Oxford)*

Fig. **21.** *Altobello Melone.* Tobias and the Angel. *Tempera on wood. Ashmolean Museum, Oxford.* *(Photo: Ashmolean Museum, Oxford)*

Possibly, our panel and the two in Oxford (that is, the Picenardi triptych) are from an altarpiece seen in the church of Sant'Elena, Cremona, by Paulus Merula in the seventeenth century. Merula refers to the altarpiece as follows: "the Virgin with the Christ Child and on the sides, the Archangel Raphael and Saint Helen."[5] The author identifies one of the panels as a representation of the Archangel Raphael rather than of Tobias and the angel. We should recall, however, that in the story of Tobias, as told in the Book of Tobit, one of the books of the Apocrypha, he is accompanied by Raphael.

Recently, scholars have convincingly linked three other panels to the Picenardi triptych, as possible predellas. They are a *Saint Helen Questioning Judas* (Fig. 22), and a *Finding of the True Cross* in the Musée des Beaux-Arts, Algiers (Fig. 23), and a *Proving of the True Cross* (Fig. 24), both recently acquired by the Museum of Art and Archaeology, University of Missouri–Columbia.[6]

This reconstruction (Fig. 25) presents at least two major problems, one of which has to do with the measurements given by Sacchi. He says that the "triptych" he saw was 112 cm high and 142 cm wide. Together our panel and the Oxford panels, which are each about 112 cm high and measure 142.3 cm in total width, are compatible with Sacchi's measurements. Apparently, when Sacchi measured the three panels they were not in a frame. Had they been, the dimensions certainly would have been greater. We should notice, too, that his measurements are not compatible with predella panels, which, in any case, he does not mention. We may assume, then, that when Sacchi saw the three panels the altarpiece to which they originally belonged already had been dismantled, and the original altarpiece could have contained both additional side panels and a predella.

There are, however, certain features that support the reconstruction. For example, the handling of the paint is consistent throughout the three large panels. According to Sydney J. Freedberg, "A subtly worked calligraphy, made of threads of light, instills power in the quiet forms, and a shimmering illumination suffuses colours. The persons in the triptych resemble Romanino's, but they have been made more poignant, given a deliberately unbeautiful Germanic cast."[7] Also supporting the proposed reconstruction is the fact that the width of each predella panel is virtually the same as the width of each of the large panels.

There are also significant thematic connections among the various panels. While gazing at the infant Christ in the central panel, Saint Helen embraces the cross on which the adult Christ was crucified. The Christ child in the central panel, who holds a bird (see Cat. No. 9), in turn looks toward the fish held by Tobias, thus connecting him with one of his conventional symbols. The Archangel Raphael instructed Tobias to make a salve out of the fish's organs,

5. "La Vergine col Bambino e ai lati l'Arcangelo Raffaele e Sant'Elena" (Paulus Merula, *Santuario di Cremona*, 226–27 [cited by Francesco Frangi, in Mina Gregori, ed., *I Campi e la cultura artistica cremonese del Cinquecento*, 97]).

6. Federico Zeri ("Altobello Melone: Quattro tavole," 43) first associated the *Finding of the True Cross* (28 × 50 cm) in Algiers with the Picenardi triptych. Frangi (in Gregori, ed., *I Campi*, 96–97) identified the *Saint Helen Interrogating a Jew* (our Fig. 23) and the *Test of the True Cross* (our Fig. 24), then in a private collection in Milan (each 22.5 × 47.5 cm), as belonging to the Picenardi triptych. Mina Gregori, "Altobello e Gianfrancesco Bembo," identified a *Saint Helen Traveling to Jerusalem* (46.5 × 25.5 cm) in a private collection as a predella panel from the Picenardi triptych, but this suggestion has not been accepted by scholars.

7. Freedberg, *Painting in Italy*, 375.

and with that medicine the boy cured the blindness of his father. Christ, too, cured not only physical blindness but spiritual blindness as well. The story of Saint Helen and the finding of the True Cross in the predella panels is linked not only to the standing female saint but also to Christ, who was crucified on that very cross.

NORMAN E. LAND

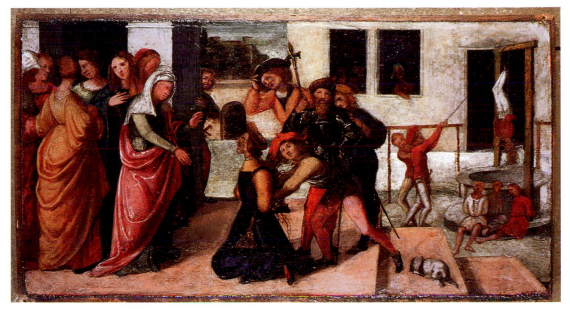

Fig. **22.** *Altobello Melone*. Saint Helen Questioning Judas. *Museum of Art and Archaeology, University of Missouri–Columbia.*

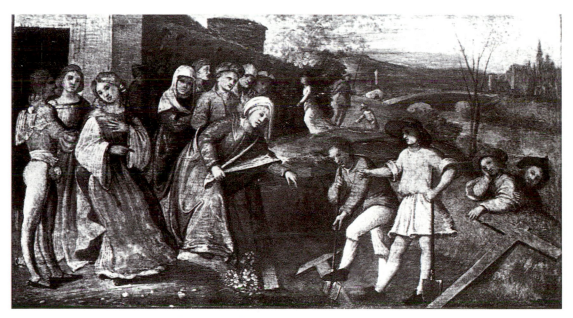

Fig. **23.** *Altobello Melone*. Finding of the True Cross. *Tempera on wood. Musée des Beaux-Arts, Algiers. (Photo: Musée des Beaux-Arts, Algiers)*

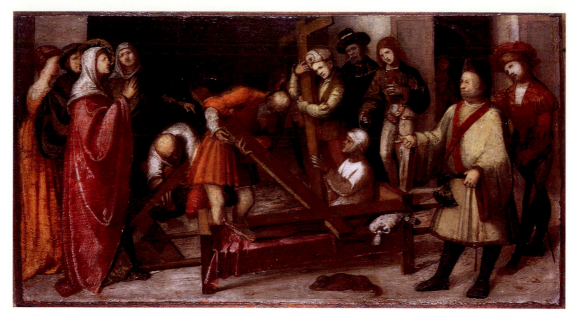

Fig. **24.** *Altobello Melone.* Proving of the True Cross. *Museum of Art and Archaeology, University of Missouri–Columbia.*

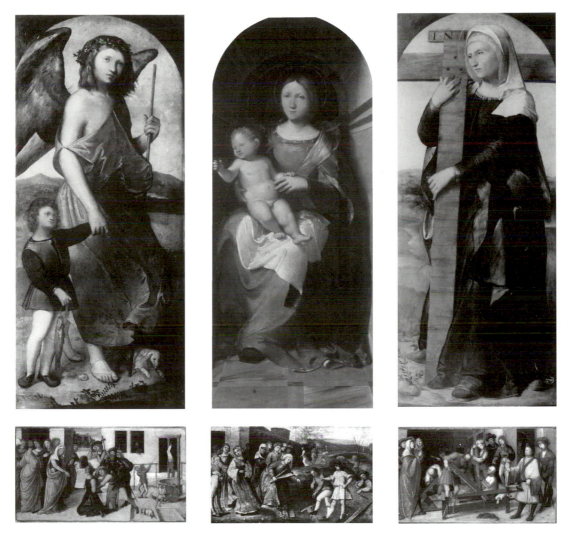

Fig. **25.** *Altobello Melone. Picenardi Altarpiece, photographic reconstruction.*

9 Bartolommeo Suardi, called Il Bramantino

Milan: ca. 1465–1530

Madonna and Child (ca. 1520)

Oil on wood. 46.3 × 36.2 cm. Museum
 of Art and Archaeology, University of
 Missouri–Columbia (61.71), Samuel H.
 Kress Collection (K 337).
Provenance: Antonio Grandi Collection,
 Milan; Contini-Bonacossi Collection,
 Florence; Samuel H. Kress Collection
 (1935).
Literature: Shapley 1968, 19; Fredericksen
 and Zeri, 35; Gian Alberto dell'Acqua
 and Germano Mulazzani, *L'opera com-
 pleta di Bramantino e Bramante pittore*, 96
 no. 38 and colorplate 57.

Early in his career Bartolommeo Suardi,
one of the foremost Milanese artists of
the early sixteenth century, assumed the
name Il Bramantino ("the little Bramante"),
probably because of his close contact with
Donato Bramante (1444–1514), the painter
and architect of Urbino whom Pope Julius II
commissioned in 1506 to design a new Saint
Peter's. Bramantino probably met Bramante
shortly after the latter's arrival in Milan in
1485. In any case, the friendship between
the two artists was strong, and it was probably
at Bramante's urging that Bramantino was
included among the first group of artists
called to Rome late in 1508 to decorate
the private apartments of Julius II in the
Vatican. Bramantino was a goldsmith before
becoming a painter, and all of his paintings
are dated after 1490, when he would have
been about twenty-five years old.[1]

1. For a concise overview of Bramantino's
career, see *Dictionary of Art*, 4:653–54.

According to Giorgio Vasari, Bra-
mantino, who was "an excellent painter
in his day," executed some frescoes for
Pope Nicholas V that were later "thrown
to the ground" by Pope Julius II. Vasari pays
tribute to the utterly convincing naturalism
of those lost works when he says that they
contained "some heads from nature, so
beautiful and so well executed that speech
alone was wanting to give them life." Vasari
also says that Raphael copied those heads
and further praises Bramantino, who was
also an architect, for having a strong sense
of design and being "the first light of a good
manner of painting that was seen in Milan."[2]

Given Vasari's enthusiasm for Bra-
mantino's work, the poor condition of our
painting, which is badly abraded across the
entire surface, is all the more lamentable.
Nevertheless, we can still date the panel with
a degree of certainty to late in the artist's
career. Moreover, we can appreciate some of
the possible meanings of the panel, which,
given its subject matter and its relatively
small size, probably served as a devotional
image. This function is also suggested by the
way in which both the Virgin and the Christ
child look directly at the viewer.

The Virgin appears half length, holding
the Christ child in her right arm and
standing or seated in front of a landscape.
Significantly, Christ is shown nude, and
in the panel's original condition his
genitals would certainly have been more
visible. According to Leo Steinberg, in the
numerous Renaissance works, including
Bramantino's haunting *Madonna and Child
with Saints Ambrose and Michael* in the
Pinacoteca Ambrosiana, Milan (Fig. 26),
that call attention to Christ's "sexual
member," it is a sign of his human nature.
In other words, when God became man
as Jesus, he also became "deathbound and

2. Vasari–de Vere, 1:398, 2:472–73

62

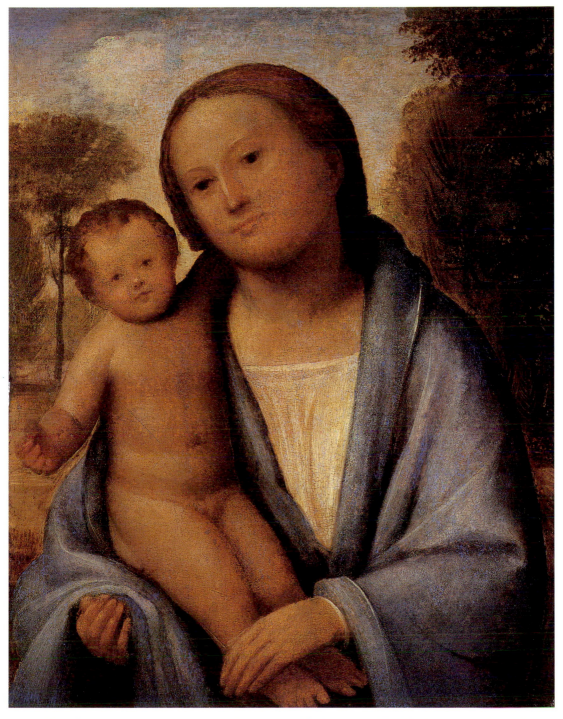

Cat. No. **9.** *Bartolommeo Suardi, called Il Bramantino.* Madonna and Child. *Museum of Art and Archaeology, University of Missouri–Columbia; Gift of the Samuel H. Kress Foundation.*

sexed," and the depiction of his genitals alludes to this, the human aspect of his being, and "serves as a pledge of God's humanation."[3]

The area around Christ's right hand is badly rubbed, and we cannot be certain of the original appearance of the object he is holding, but given its proximity to the tree in the background, we may speculate that it was a piece of fruit (see Cat. No. 3). If that was the case, the Renaissance viewer would have recalled Adam and Eve, whose sin in disobeying God's injunction against eating of the fruit of the Tree of the Knowledge of Good and Evil in the Garden of Eden cast humankind into sin. According to Christian belief, the sacrifice of Christ by crucifixion redeemed humankind of that sin. In the eye of the Renaissance viewer, there would have been a poignant contrast between the infant Christ lovingly held by his mother and his horrifying death in the future.

Another possibility is that the Christ child originally held a nut or perhaps even a bird. Saint Augustine explained the symbolism of the walnut by suggesting that the nut's outer shell is like the flesh of Christ; the shell, like the wood of the cross; and the meat, his divine nature.[4] If the tree behind Christ could be shown to be a walnut tree, the case for this reading would be very strong. Unfortunately, the poor condition of the panel makes such an identification impossible. Last, Christ might once have held a bird, perhaps a swallow or more likely a goldfinch, which symbolizes the soul of man and resurrection. Moreover, according to legend, the goldfinch received its red spot when it was splashed with the blood of Christ on his way to Golgotha.[5] Interestingly, whether fruit, nut, or bird, the object held by Christ would have suggested his future crucifixion to the Renaissance viewer.

If the figure of Christ in our painting did originally hold a bird, as he does in numerous other works from the Renaissance (for example, Cat. No. 8), it might have reminded some learned viewers of a passage in the first book of the apocryphal Infancy Gospel of Saint Thomas (15:6). There the youthful Christ is said to have "made [out of clay] the figures of birds and sparrows, which, when he commanded them to fly, did fly, and when he commanded them to stand still, did stand still; and if he gave them meat and drink, they did eat and drink."[6] In other words, some viewers might have seen Bramantino's Christ as an artist who had the ability to make his creations literally come alive, just as an accomplished Renaissance painter like Bramantino could, as Vasari implies, make his figures seem alive.

MARJORIE OCH and NORMAN E. LAND

3. Leo Steinberg, *The Sexuality of Christ in Renaissance Art and in Modern Oblivion*, 15. Alluding to the genitals of the Christ child in Bramantino's *Madonna and Child with Saints Ambrose and Michael*, Steinberg says that the painting confesses "the mystery of the dual nature of Christ and his manhood's surrender to suffering" (41). See also Steinberg's interesting discussion (128–29) of a *Madonna and Child* in the Museum of Fine Arts, Boston, attributed to Bramantino.

4. James Hall, *Dictionary of Subjects and Symbols in Art*, 330, citing Augustine.

5. For a discussion of birds as symbols in the Renaissance, see Herbert Friedmann, *The Symbolic Goldfinch: Its History and Significance in European Devotional Art*, 7–35.

6. *The Lost Books of the Bible and the Forgotten Books of Eden*, 52. The story of Christ as artist is briefly discussed in Otto Kurz and Ernst Kris, *Legend, Myth, and Magic in the Image of the Artist: A Historical Experiment*, 59–60. Friedmann, *Symbolic Goldfinch*, mentions a legend in which the companions of Christ bring him clay birds that he miraculously brings to life (8, 114–15, 170 n. 1).

Fig. **26.** *Bramantino.* Madonna and Child with Saints Ambrose and Michael. *Tempera on wood.*
Pinacoteca Ambrosiana, Milan (Photo: Art Resource)

10 Paris Bordone

Treviso and Venice: 1500–1571

Athena Scorning the Advances of Hephaestus (ca. 1555–1560)

Oil on canvas. 139.4 × 127.7 cm. Museum of Art and Archaeology, University of Missouri–Columbia (61.78), Samuel H. Kress Collection (K 1112).

Provenance: Edward Solly, London (sold Christie's London, May 8, 1847, no. 1, as Bordone; bought by Anthony); Frederick Leighton (Lord Leighton of Stretton), London (sold Christie's, London, July 14, 1896, no. 349, as Bordone; bought by R. Legg); Marchese Doria, Genoa; Contini-Bonacossi Collection, Florence; Samuel H. Kress Collection (1937).

Literature: Fredericksen and Zeri, 32; Shapley 1973, 36; *Illustrated Museum Handbook*, 76; Sylvie Béguin, "Paris Bordon en France," 10, fig. 2; Giordana Mariani Canova, "Paris Bordon: Problematiche chronologiche," 146, fig. 16; Margaret Reynolds Chace, ed., *A Gift to America: Masterpieces of European Painting from the Samuel H. Kress Collection*, 72, fig. 1; Christine E. Thede and Norman E. Land, "Erotica veneziana: Paris Bordone's *Athena Scorning the Advances of Hephaestus*."

Inscription: O[PUS]. PARIDIS BORDONO (at lower left)

Paris Bordone translated the colors and formal groupings of the Venetian tradition of Giorgione and Titian into a distinctly Mannerist language. Typical of the artist's oeuvre is our painting depicting Athena scorning the advances of Hephaestus, a signed work that shows the god in a closely framed composition in which the setting is suggested by the fireplace or forge on the left and a smattering of clouds behind Athena on the right. Exaggerated musculature, biting color tonalities, sophisticated brushwork, and slightly awkward limb arrangements are all characteristic of the work of Bordone, particularly in the period from 1550 to 1560, the years to which this painting has been dated. In spite of these seeming limitations, however, the results are pleasing, sometimes erotic, images in which color, flesh, and compositional sophistication actively contribute to the viewer's enjoyment.

Bordone was born in Treviso in 1500. After the death of his father when he was eight years old, he moved to Venice, where he later came under the influence of the work of both Giorgione and Titian.[1] Other artists instrumental to the development of his art include the architect Sebastiano Serlio, the Venetian painter Giovanni Antonio Pordenone, and the Lombard Moretto da Brescia. Bordone worked in Venice off and on throughout his career and painted some of the major commissions awarded to artists there during his lifetime. He also traveled outside Venice, spending some time at the French court in Fontainebleau, although the date of this activity has been debated. While Vasari recorded that Bordone was called to the French court in 1538 to serve King Francis I, most scholars now place Bordone's longer French sojourn between the years 1559 and 1561 in service to Francis II, while accepting a brief visit

1. For more about Bordone and his career (with further bibliography), see *Dictionary of Art*, 4:398–401.

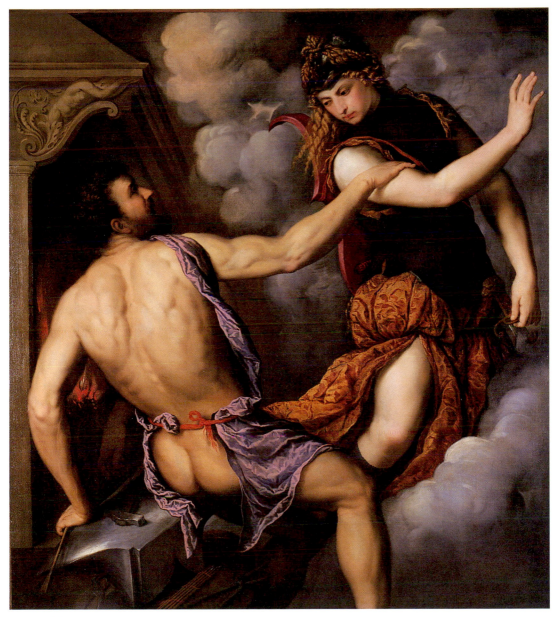

Cat. No. **10.** *Paris Bordone.* Athena Scorning the Advances of Hephaestus. *Museum of Art and Archaeology, University of Missouri–Columbia; Gift of the Samuel H. Kress Foundation.*

in 1538.[2] Bordone also worked for the Fuggers in Augsburg and for Carlo da Tho in Milan. He spent his last years in Venice, where Vasari met him in 1566, and died there of a fever in 1571 at the age of seventy.

This *Athena Scorning the Advances of Hephaestus* has been linked to the *Jupiter and Io* in the Konstmuseum, Göteborg, Sweden (Fig. 27), because of its shared mythological subject and its similar formal arrangement and size.[3] Our painting is dated to the later 1550s because of its similarity to the picture in Göteborg, a work Vasari records as having been painted while the artist was living at the French court and which scholars place during the period of his second visit.

Attempts to identify the subject of the painting have generated several different opinions. Most often it has been identified as depicting the story of Thetis and Hephaestus from Homer's *Iliad* (XVIII), an identification that can be traced as far back as Jean Paul Richter's reference to the painting in an exhibition review of 1882.[4] The sense of Bordone's painting, however, does not fit the details of Homer's story.

In *The Iliad,* Hephaestus was very fond of Thetis and happy to oblige her request that he make weapons and armor for her son, Achilles, a job he executed quickly. Thetis left the forge, carrying her son's armor, delighted with the work that Hephaestus had done and anxious to present the arms to Achilles. In Bordone's painting, the woman wears rather than carries the armor, and she does not appear pleased. In fact, the painting depicts a moment of confrontation, not congratulation, in which Hephaestus places his hand on the woman's upper arm as she pulls away. Furthermore, the attempt to reconcile the painting with Homer's narrative fails to take into account the fleshy erotic quality of the image and Hephaestus's rather unusual position—he leans against the anvil at his left rather than sitting on it.

Most likely because of the painting's sensuality, Bernard Berenson proposed the subject as Aphrodite and Hephaestus, although no specific narrative can be assigned to this title.[5] Recently, Giordana Mariani Canova, the leading scholar on Bordone, changed her earlier identification of the subject from Thetis and Hephaestus to Athena and Hephaestus.[6] Canova's suggested title does acknowledge that the attributes of the female figure are more befitting Athena than Thetis. Undoubtedly the title is partly based on our figure's similarity to the Athena in Bordone's painting in the Birmingham Museum of Art, Birmingham, Alabama (Fig. 28). The action of the narrative, however, can be correlated more closely with the story of the birth of Erichthonius, told by several ancient authors.

2. Vasari–de Vere, 2:800, noted that Bordone completed commissions for the cardinal of Lorraine and for the duke of Guise. A number of scholars have suggested that these two men were most likely the sons of Claude of Lorraine—Francesco, the second duke of Guise, and Charles, the cardinal, commonly referred to as the cardinal of Lorraine. Pellegrino Orlandi, writing in the early years of the eighteenth century, noted that Bordone was in France in 1559 (*Abecedario pittorico,* 311 [cited by Sylvie Béguin, "Paris Bordon en France," 9, 25]). For the possibility of two visits, see *Dictionary of Art,* 4:401.

3. The traditional title for this painting is *Jupiter and Io,* using the Roman rather than the Greek names, and this convention has been followed here. Other Bordone mythologies are identified more commonly (although not exclusively) with the Greek names.

4. Jean Paul Richter, "Ausstellung Alter Meister in Burlington House."

5. See Bernard Berenson, *Italian Pictures of the Renaissance: Venetian School,* 1:47.

6. For the different titles, see Giordana Mariani Canova, *Paris Bordon,* 59, 103, and fig. 134, and "Paris Bordon: Problematiche chronologiche," 146, fig. 16, respectively.

Fig. **27.** *Paris Bordone.* Jupiter and Io. *Oil on canvas. Konstmuseum, Göteborg, Sweden. (Photo: Konstmuseum, Göteborg)*

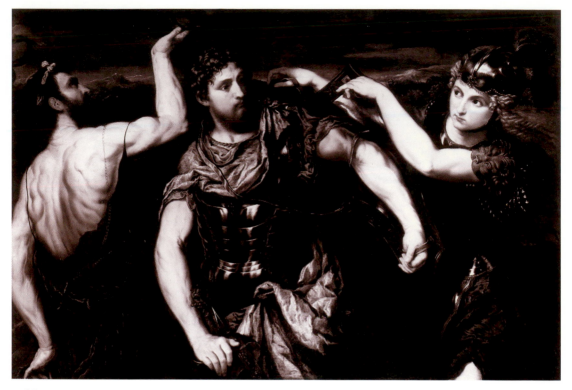

Fig. **28.** *Paris Bordone*. Hermes and Athena Arming Perseus. *Oil on canvas. Collection of the Birmingham Museum of Art, Birmingham, Alabama; Gift of the Samuel H. Kress Foundation. (Photo: Birmingham Museum of Art, Birmingham, Alabama)*

The source for Bordone's painting is the version of the story told by Apollodorus of Athens. Athena came to Hephaestus to ask him to fashion some arms. He, having been forsaken by Aphrodite, fell in love with Athena and began to pursue her. When after much trouble due to his lameness he was able to get near to her, he attempted to embrace her; but she, being a chaste virgin, would not submit to him and tried to flee. In the ensuing struggle, he ejaculated on her leg. In disgust, she wiped the seed off with wool. As she fled, Hephaestus's seed fell on the ground and impregnated it, a union that produced Erichtonius.[7]

7. See Apollodorus, *The Library,* 3:4–6. See also Robert Graves, *The Greek Myths,* 96–97, which lists

In Bordone's painting, Hephaestus attempts to embrace the goddess. Athena's arm and stance suggest that she will presently escape, while her face records her displeasure at the god's advance. Lameness as well as the unsuccessful attempt at physical intimacy may account for Hephaestus's awkward pose, and the prominence of Athena's thigh suggests the events that ultimately led to the birth of Erichthonius. Bordone often featured arching, exposed limbs prominently in his

the numerous versions of the story. Good synopses of the major accounts are given in Benjamin Powell, *Erichthonius and the Three Daughters of Cecrops,* 1–6. For a discussion of the iconography of the painting, see Christine E. Thede and Norman E. Land, "Erotica veneziana: Paris Bordone's *Athena Scorning the Advances of Hephaestus.*"

work of Bordone; in this case, his propensity for sensual display ideally suited his subject.

Bordone rarely depicted specific mythological stories, more often rendering groups of half-length gods and goddesses in a frieze arrangement. Significantly, in at least two if not three paintings—the Birmingham *Perseus* (Fig. 28), the *Jupiter and Io* in Göteborg (Fig. 27), and our painting—Bordone depicted narrative with some degree of accuracy, which may point to a common patron.[8] The attention to narrative detail also lends further support to the theory, advanced by several art historians, that *Jupiter and Io* and *Athena Scorning the Advances of Hephaestus* were originally conceived as pendant paintings.[9]

JUDITH MANN

8. The Birmingham painting has been associated with the story of Perseus's quest to obtain the head of the gorgon Medusa, a quest in which he was aided by Hermes, who gave him a sword to cut through Medusa's scales, and Athena, who provided him with a highly polished shield to mirror the monster's petrifying face. All of these details are faithfully recorded by Bordone. In the Göteborg painting, Bordone accurately depicted the myth of Jupiter and Io from Ovid's *Metamorphoses* (1.590–625), where Jupiter falls in love with the nymph Io, carries her up to Olympus, and then tries to cover her to conceal her from Hera's jealous view. Bordone has depicted Jupiter attempting to cover Io, even sacrificing some of the inherent eroticism to do so.

9. See Béguin, "Paris Bordon en France," 10. Shapley 1973, 36, discounts this theory based on the later style of the Göteborg painting as well as the fact that the two works are not the same size.

11 Attributed to Carlo Francesco Nuvolone

Milan: 1609/10–1661/62

Portrait of Giovanni Battista Silva
(ca. 1660)

Oil on canvas. 106.7 × 76.2 cm. Museum
 of Art and Archaeology, University of
 Missouri–Columbia (61.79), Samuel H.
 Kress Collection (K 1180).
Provenance: Private Collection, Milan;
 Contini-Bonacossi Collection, Florence;
 Samuel H. Kress Collection (1939).
Literature: Fredericksen and Zeri, 3 (as
 Filippo Abbiati); Shapley 1973, 95.
Inscriptions: Per V[ostra] S[ignoria]
 M[olto] Ill[ustre] Sig[nore] Gio[vanni]
 Batt[ist]a Silva Mio Sig[nore] ecc. Sue
 Mani.

The personality and career of Carlo
Francesco Nuvolone, who should not
be confused with his brother, Giuseppe
Nuvolone (1619–1703?), also a Milanese
painter, have not yet been fully examined by
scholars. The exact dates of Carlo's birth
and death are also unknown.[1] Trained
by his father, Panfilo (1581–1651?), he
went on to run, in the words of Rudolf
Wittkower, "the most flourishing school in
Milan" in the middle of the seventeenth
century.[2] Nuvolone was celebrated by
contemporaries as a gifted portrait painter
of the nobility and was known by the
nickname "Guido lombardo" (the Lombard
Guido), a reference to the similarity of his
palette to that of Guido Reni, who also
used pale tones in many of his works.

Nuvolone was probably most influenced
by the work of his fellow Lombard Giulio
Cesare Procaccini, a Genoese painter whose
surfaces shimmer with light, deftly applied
brush strokes.

The lightness of touch and the deft
handling of paint are among the most
notable features of our portrait. The subject,
shown standing in front of an upholstered
chair, is dressed in black with a large white
linen collar. He carries a coat or cape over
his right arm, while in his left hand he holds
a glove. With his bare right hand he grasps
a folded paper with an inscription that
begins, "For your most illustrious Lordship
Giovanni Battista Silva, my master, etc.";
this address is followed by instructions to
deliver the letter into Silva's hands ("Sue
Mani"). Silva was a member of a Milanese
family, most likely the son of the wealthy
Gian Antonio Silva, who died in 1647.

The attribution of our painting to
Nuvolone is not certain, although it appears
stylistically closer to his work than to that of
the other artists whose names have been
associated with it, specifically Francesco
del Cairo and Filippo Abbiati.[3] Cairo's
more mannered and animated style is not
present in the Silva portrait, and the faces
of Abbiati's figures are firmer and lack the
softness of touch that distinguishes the work
of Nuvolone.

Nuvolone's paintings are noted for their
feathery brush strokes and general softness
of appearance, qualities that are evident in
the skin tones and the delicacy of the hair
in the Silva portrait.[4] A comparison of this
painting with other examples of Nuvolone's
portraiture in the Castello Sforzesco in
Milan and the Museo Civico in Bologna

1. For relevant bibliography on Nuvolone and
his family, see *Dictionary of Art*, 23:319–21.
2. Rudolf Wittkower, *Art and Architecture in
Italy, 1600–1750*, 350. We should note, however,
that Wittkower describes this period in Milanese
art as lacking in artistic genius.

3. Shapley 1973, 95. Shapley also tentatively
suggested the Bolognese painter Benedetto
Gennari as the artist responsible for our painting.
4. Ibid.

Cat. No. **11.** *Attributed to Carlo Francesco Nuvolone.* Portrait of Giovanni Battista Silva. *Museum of Art and Archaeology, University of Missouri–Columbia; Gift of the Samuel H. Kress Foundation.*

reveals strong parallels in the brushwork of the face and hair as well as the carefully controlled palette and general demeanor of the sitter.[5] This dark, earth-toned palette recalls the work of the Spanish artists Diego Velázquez and Francisco de Zurbarán and testifies to the close ties between the art of the Northern Italian and Spanish schools in the seventeenth century. Nuvolone was sometimes called "Murillo lombardo" (the Lombard Murillo), because his work recalls the style of the Sevillian painter Bartolomé Esteban Murillo, who is also known for his delicate brushwork.[6]

In depicting Silva, Nuvolone has observed the etiquette of contemporary dress. Silva has removed his hat and holds it in his hands. In the seventeenth century hats were almost always worn, save in the presence of royalty or when visiting, and were removed only momentarily when greeting a social better.[7] Here Silva holds his hat properly against his torso (the habit of holding the hat lower, against the thigh, was regarded as an outmoded fashion of the sixteenth century)[8] and does not appear ready to replace it, thus indicating that he is a guest in someone else's house. Silva has also removed his right glove, again an observance of proper social custom because

gloves were removed from only the right hand in order to receive objects that were proffered.[9] Although more widely worn in the seventeenth century than in the sixteenth, gloves were still objects of luxury and reflected wealth and status. Figures shown with one hand gloved and the other holding a glove often have been interpreted as conveyers of allegorical meaning, notable examples being Titian's famous *Man with a Glove* in the Louvre, Paris (Fig. 29), or Rembrandt's *Portrait of Jan Six* (Amsterdam, Six Collection).[10] Silva's gloves, then, convey his elevated social position and his observance of the correct rules of social intercourse.

Through his careful observation of fashion and the nuances of social interaction, Nuvolone created a sophisticated example of the expressive dynamism of Baroque portraiture. By noting the position of the hat, the viewer understands that Silva, a visitor, has just arrived at his destination. The unopened note, seemingly given to Silva only moments before, reinforces this sense of recently transpired events. Thus,

5. The *Portrait of a Woman* now in the Castello Sforzesco, on deposit from the Palazzo Marino, Milan, is reproduced in Mercedes P. Garberi, *Il Castello Sforzesco: Le raccolte artistiche: Pittura e scultura,* 137; the *Portrait of a Woman,* from the Museo Civico, Bologna, is in Germano, *Il seicento lombardo: Catalogo dei dipinti e delle sculture,* cat. no. 213, pl. 234.

6. Garberi, *Il Castello Sforzesco,* 161.

7. On the etiquette of the hat in the seventeenth century, see Joan Wildeblood, *The Polite World: Guide to the Deportment of the English in Former Times,* 98–101.

8. Ibid., 101. Wildeblood cites F. De Lauze, *Apologie de la Danse* (1623), as the source for this information.

9. On the history of gloves and their proper use, see Max von Boehn, *Modes and Manners, Ornaments: Laces, Fans, Gloves, Walking Sticks, Parasols, Jewelry, and Trinkets,* 78–88; and Wildeblood, *Polite World,* 103.

10. On the glove as a symbol of the courtier's fidelity, see Jean Pierre Habert, "*Portrait de jeune homme* dit *L'Homme au gant*," 373; on the glove as a symbol of humanist elegance, see Habert's "Man with a Glove," 192. Lorne Campbell, *Renaissance Portraits: European Portrait-Painting in the 14th, 15th, and 16th Centuries,* argues against any symbolic meaning for gloves in general (99), although he acknowledges that old, tattered gloves may convey erotic meaning (134), but not necessarily in Titian's painting. On the significance of the pulling on of gloves in Rembrandt's portrait of Jan Six, see Svetlana Alpers, *Rembrandt's Enterprise: The Studio and the Market,* 93, and David R. Smith, *Masks of Wedlock: Seventeenth-Century Dutch Marriage Portraiture,* 79.

Fig. **29.** *Titian*. Man with a Glove. *Oil on canvas. Louvre, Paris. (Photo: Art Resource)*

the artist has introduced the suggestion of time into his painting. He has shown his subject as an active participant in upper-class Milanese society and not as a stately gentleman observed and recorded in timeless serenity. The folded paper enlivens the painting further because it breaks down the barrier between subject and observer. The viewer of the painting is placed in a position similar to that of the person who delivered the note and is thus invited to approach Giovanni Silva and share his presence.

Keeping the inscription in mind, we might also read the letter as a missive from the artist to his sitter ("mio Signore"). "My master" might then be an allusion to Nuvolone's delivery of the painting into the hands ("Sue Mani") of Silva. The artist refers both to the moment when Silva received a note from someone, perhaps his host, and the actual completion and delivery of the portrait to its owner. If this is the case, the note transforms the painting into a remarkably sophisticated interaction among subject, artist, and viewer. The viewer is involved in one moment in the transfer of the note from host to visitor and, in the next, in the artist's presentation of the painting to the sitter. In other words, the viewer responds to the painting both as an illusion of Silva in a particular time and space and as a work of art—as paint on canvas. This involvement of the viewer in the space and action of the painting is typical of the best of Baroque portraiture and indicates that the author of this painting was adept at the most sophisticated techniques of Baroque drama and spatial experimentation.

JUDITH MANN

12 Giuseppe Bazzani

Mantua: 1690–1769

A Laughing Man (ca. 1735)

Oil on canvas. 76.2 × 61.6 cm. Museum of Art and Archaeology, University of Missouri–Columbia (61.72), Samuel H. Kress Collection (K 344).
Provenance: Contini-Bonacossi Collection, Florence; Samuel H. Kress Collection (1939).
Literature: Fredericksen and Zeri, 21; Shapley 1973, 114–15; Rudolf Wittkower, *Art and Architecture in Italy, 1600 to 1750,* 478.

The son of a goldsmith, Giuseppe Bazzani worked primarily with religious and classical subjects. He was a pupil of Giovanni Canti (1653–1715), a painter from Parma, who probably introduced the young Bazzani to the grand Baroque tradition of the Carracci, Rubens, and Frans Hals. Bazzani's dramatic works of the 1740s were strongly influenced by the contemporary theater, and his brushwork has a bravura akin to dramatic movement. In his late work, however, he turned to the lighter approach of the Rococo. He spent most of his career in his native city of Mantua, where he became a member of the Academy of Fine Arts in 1752 and the group's director in 1767, indicating that he was esteemed by both patrons and fellow artists.[1]

Much remains to be learned about the artist. For example, because he was already fifty when he painted his first securely dated work, the *Consignment of the Keys to Saint Peter* of 1739 in the parish church at Goito, the style of his early work is a mystery. The painting at Goito, however, is similar in style to our painting, which on the basis of that similarity has been dated to ca. 1735. Our painting represents an unusual subject among Bazzani's works and shows the influence of seventeenth-century genre painting, as well as eighteenth-century Italian theater.

There have been a number of suggestions concerning the subject of our painting. Nicolai Ivanoff, for example, titled the work *Lo Scemo,* thus identifying the figure as a stupid or silly man.[2] Other, similar interpretations are that he is a comedian or an imbecile.[3] These interpretations clearly rest upon a reading of the figure's gesture and facial expression, which can be seen as comic, insane, or demonic. In any case, these interpretations assume that Bazzani wanted to represent not a specific individual but a certain type of person, such as a comedian or a lunatic.

Our painting's plain background and earthy colors and the subject's confrontation with the viewer all point to Bazzani's awareness of Baroque genre scenes and his successful adaptation of this subject matter. Indeed, both his loose brush stroke and the subject matter are frequently compared to Frans Hals's portraits of laughing men and women, a commonplace subject in seventeenth- and eighteenth-century painting. Our figure's theatrical expression is also reminiscent of the earlier work of Hals, such as his *Malle Babbe* of ca. 1630–1633 in the Staatliche Museen, Berlin-Dahlem, which represents a kind of town witch.

In our painting, Bazzani's contribution to the genre tradition is the figure's theatrical movement toward the viewer, which, combined with the sinister expression, suggests a character from the popular

1. For more information about Bazzani and for further bibliography, see *Dictionary of Art,* 3:436–37.

2. Nicolai Ivanoff, *Bazzani,* 79, fig. 78.
3. See Shapley 1973, 114–15.

Cat. No. **12.** *Giuseppe Bazzani.* A Laughing Man. *Museum of Art and Archaeology, University of Missouri–Columbia; Gift of the Samuel H. Kress Foundation.*

commedia dell'arte. The immediacy of style and gesture are closely connected to contemporary Mantuan interests in theater, an art that flourished in this princely province of the Hapsburg empire. Most likely our painting was one of several paintings produced by this prolific artist on theatrical themes.

Because of the unusual and enigmatic gesture and facial expression of the figure, some scholars have suggested that our painting is a fragment of a larger work.[4] That is to say, because the figure's action is so difficult to interpret with certainty, some have assumed that there must have been other figures with it. The tacit assumption is that the missing figures would have presented a recognizable context within which to understand the extant figure.

Another possibility is that our painting is neither the remains of a larger work nor a standard representation of a specific type of person. Given the application of the paint, which is rather loose, even for Bazzani, and the unusual way in which the figure seems to lunge toward the viewer, as if to grab him or her, the painting might be a kind of self-portrait in the guise of a theatrical person. Artists of the seventeenth and eighteenth centuries often studied their own faces as models for emotional expressions. Bernini, for instance, is said to have used his face as a model for his *Anima Dannata* (Fig. 30) of ca. 1619 in the Palazzo di Spagna, Rome, and his *David* of 1623–1624 in the Galleria Borghese, Rome.[5] Perhaps, then, our painting records Bazzani's rapid and summary study of his own facial expression and gesture. In that case, the painting is not a finished work of art in the usual sense, but a study or sketch.

MARJORIE OCH and NORMAN E. LAND

4. Ibid., 114.

5. See Howard Hibbard, *Bernini,* 31, 66. John R. Martin, in *Baroque,* discusses other artists who studied their own features and emotions (74).

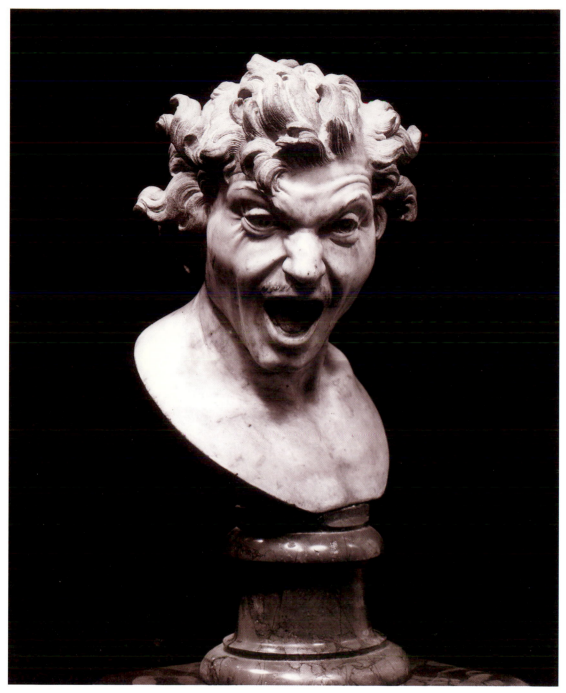

Fig. **30.** *Gianlorenzo Bernini*. Anima Dannata. *Marble. Palazzo di Spagna, Rome. (Photo: Art Resource)*

13 Pietro Antonio Rotari

Verona and St. Petersburg: 1701–1762

Young Woman with a Sprig of Jasmine (ca. 1756–1762)

Oil on canvas. 46.4 × 38.8 cm. Museum of Art and Archaeology, University of Missouri–Columbia (61.82), Samuel H. Kress Collection (K 1590).

Provenance: Catherine II, Empress of Russia, St. Petersburg; Collection of A. Seligman, New York;[1] Paul Drey Gallery, New York; Samuel H. Kress Collection (1948).

Literature: Fredericksen and Zeri, 179; Shapley 1973, 157; *Illustrated Museum Handbook,* 82; Donald Garstang, "Two Idealized Heads of Young Girls"; Leslie Griffin Hennessey, "Head of a Girl," 287, fig. 3.

When Pietro Rotari arrived in Russia in 1756, he had already established himself as a portraitist and narrative painter, first in Verona and then in Dresden. He continued to produce large-scale narrative paintings in Russia and while there also perfected another kind of subject matter, single figures of young women with expressive faces, for which he is still admired. Our painting is a good example of this type of picture and is among the best known of the more than six hundred versions that the artist produced. The young woman in our picture wears a pink satin gown edged with a ruffle and a dark blue mantle or coat lined in white. A sprig of jasmine is tucked into her bodice, and a black lace ribbon adorns her neck. She sits in an oval-backed chair draped with a striped silk shawl. Her moist, sparkling eyes, which engage the viewer directly, and her sensuous lips, parted to expose her lovely teeth, convey a gentle eroticism that is characteristic of Rotari's work in this genre. Her prominent earrings enhance this sensuous dimension of the painting, for pearls are often associated with Venus, goddess of love, who was born from the sea.

Pietro Rotari was born in Verona in 1707.[2] At the age of seven he was apprenticed to the Belgian painter Robert van Auden Aert, and soon thereafter he studied with Antonio Balestra, who oversaw his development as both painter and engraver. In 1726, Rotari went to Venice, where he studied works by Giambattista Tiepolo and Piazzetta. The following year, he relocated to Rome, working first under Francesco Trevisani and then with his fellow Veronese, Francesco Biancolini. In 1731, he traveled to Naples, where he studied under Francesco Solimena and then became the director of a school of drawing initiated by Ferdinand IV. In 1734, bringing with him seventy-eight paintings, he returned to his native city, where he set up his own studio and eventually a school. His stature grew steadily, and in 1740 the Venetian senate gave him the title of count. In 1749 he moved to the Austrian court, where he met and worked with the Swiss artist Jean-Etienne Liotard, whose fashionable images of costumed women were important for Rotari's later work. From Vienna, Rotari was summoned by King Frederick Augustus III to Dresden. For the princes and princesses of Frederick's Saxon court, Rotari fashioned many successful portraits that captured the personalities of the sitters and recorded the

1. Giuseppe Fiocco, "Di Pietro Rotari (e d'un Libro che Lo riguarda)," 278, locates the painting in the Seligman Collection.

2. For more about Rotari and his life, see Marco Polazzo, *Pietro Rotari pittore veronese del Settecento,* and *Dictionary of Art,* 27:213.

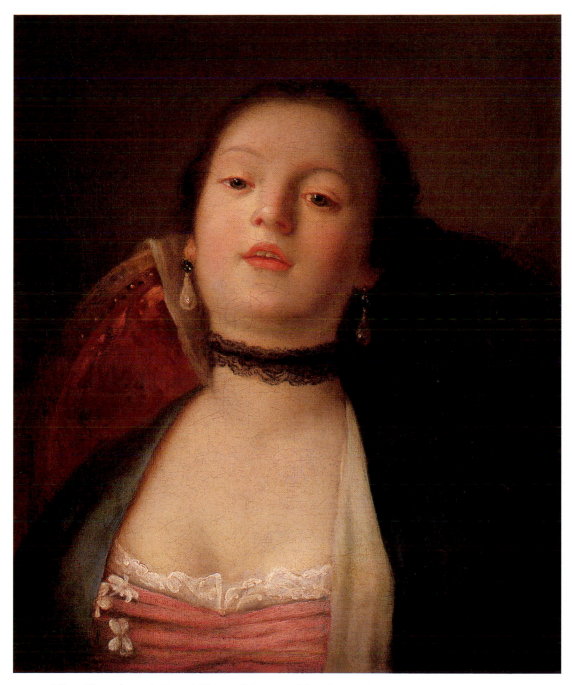

Cat. No. **13.** *Pietro Antonio Rotari*. Young Woman with a Sprig of Jasmine. *Museum of Art and Archaeology, University of Missouri–Columbia; Gift of the Samuel H. Kress Foundation.*

details of fashion and the nuances of status that were essential in court portraiture. From Dresden the artist was summoned to St. Petersburg by Empress Elizabeth Petrovna, who spared no expense in arranging for his relocation. Rotari's Russian career was cut short by his untimely and somewhat mysterious death brought on by a violent stomach ailment after his dinner on August 31, 1762.

According to the nineteenth-century diarist Augustus B. Granville, the empress, who was the daughter of Peter the Great, commissioned Rotari to travel through her empire and record the beauty of its natives.[3] That Rotari probably never made such a trip is suggested by the resulting series of 638 small heads ("testine") that now hangs in the Peterhof. These portraits include only eight different sitters, young women whom undoubtedly he befriended in St. Petersburg.[4] Nonetheless, he was sensitive to details of costume and personality, which he translated effectively into engaging images. Rotari developed the popular type of portrait head that combines a lifelike sense of the sitter with a range of playful emotions while he worked in Dresden. In Russia, however, he fully exploited the potential of this genre, as is evidenced by our painting.

These images were not conceived as unique renderings of the physiognomies of individuals, in spite of the fact that our painting has been identified as a portrait of the artist's wife.[5] Moreover, in this type of picture the details of costume, setting, and accessories, along with the observer's point of view, could be changed to suggest various moods and personalities. Rarely are the emotions extreme.

Our picture is known in at least seventeen versions (see the list at the end of this entry). All of them display the somewhat stiff pose, the pearl-drop earrings, and the downward gaze. Other details, including the color of the hair, the expression of the mouth, the background, the presence or absence of a flower, and the design of the bodice vary from picture to picture. The version closest to our painting was sold recently on the London art market and is now in a private collection (Fig. 31).[6]

Scholars differ in their identifications of the originator of this image. Some have traced the original concept to a pastel attributed to François Boucher, now lost but known in several copies (for example, Fig. 32).[7] Still, because the angle of the head coupled with the slightly opened mouth creates a more active eroticism than is characteristic of many of the images that Rotari produced in Russia but is less typical of the more removed, passive beauties that Boucher created, at least one scholar has questioned whether Boucher was the original author of this type.[8] While piecing together a definitive sequence for the many versions of this image is difficult, the source

3. See Augustus Bozzi Granville, *Saint Petersburg: A Journal of Travels to and from That Capital*, 2:512. See also Audrey Kennett, *The Palaces of Leningrad*, 206.

4. Kennett, *Palaces of Leningrad*, 206, has identified eight different models wearing many different costumes.

5. See Shapley 1973, 158, concerning the title of the painting.

6. See Donald Garstang, "Two Idealized Heads of Young Girls." I wish to express my warm thanks to Donald Garstang for his patience and generosity in sharing his knowledge with me.

7. The pastel is listed in the inventory of the sale of the collection of Jacques-Onésyme Bergeret, published in Georges Wildenstein, "Un Amateur de Boucher et de Fragonard: Jacques-Onésyme Bergeret," 67, no. 41, fig. 25. See also Garstang, "Two Idealized Heads," and Baumann in *Illustrated Museum Handbook*, 82.

8. See Shapley 1973, 158, and Leslie Griffin Hennessey, "Head of a Girl," 286.

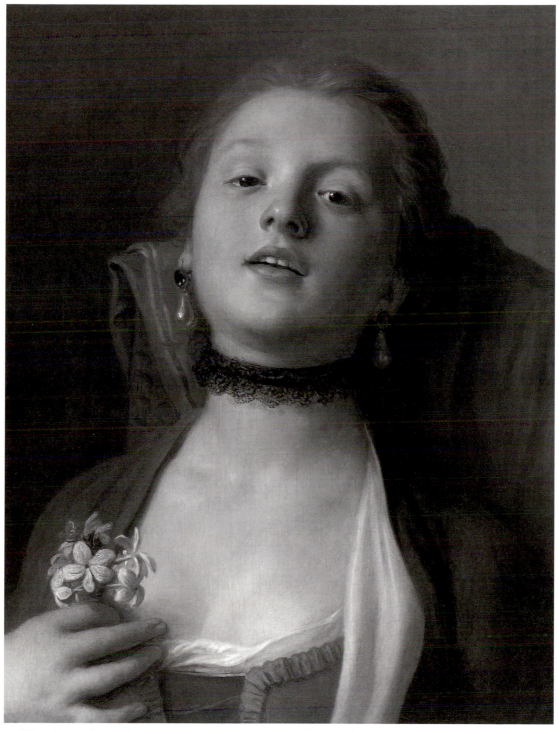

Fig. **31.** *Pietro Rotari.* Young Woman. *Oil on canvas. Private Collection, Spain.*

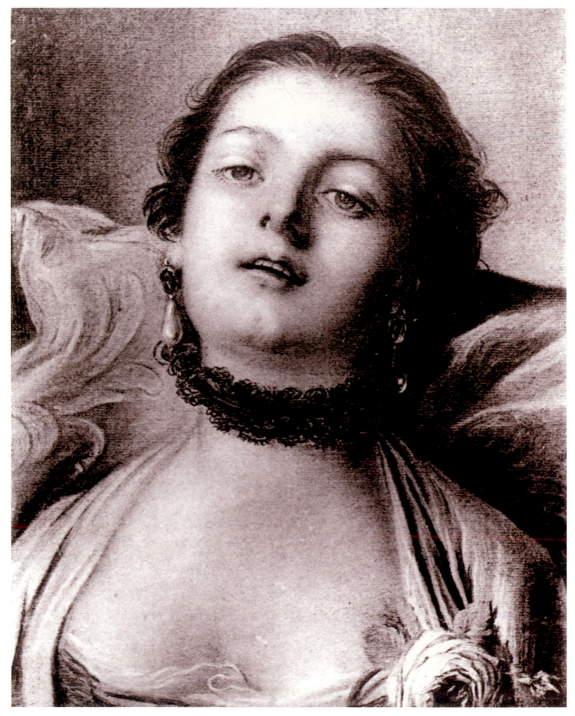

Fig. **32.** *Anonymous.* Young Woman. *Pastel. Copy of lost painting by François Boucher (?). Whereabouts unknown.*

may ultimately prove to be Rotari, given the easy communication between Paris and St. Petersburg in the eighteenth century. One argument in favor of Rotari as creator of the image is that the pose seems to have been developed for a sitter in a chair, as in our painting, rather than for a sitter in front of a pillow, as depicted by Boucher. In other words, the stiff neck and oblique angle of the gaze are more consistent with the use of the chairback without a pillow.

At its best and in its many varieties, the type of image exemplified in *Young Woman with a Sprig of Jasmine* conveys coyness, shy naïveté, mild eroticism, and playful contemplation, precisely those values that one associates with the salon style of the Rococo. While Rotari did on occasion turn his attention to young men, he seemed far more at home in the company of these young women, whom he dressed and draped in a variety of clothing and viewed from diverse angles to create pleasing records of Russian costume and the fresh appeal of playful youth.

Known Versions of Pietro Rotari's *Young Woman with a Sprig of Jasmine*

1. A head in the so-called Rotari Room (the Cabinet of Modes and Graces) in the Peterhof, St. Petersburg. See Marco Polazzo, *Pietro Rotari pittore veronese del Settecento,* figs. 151, 177.

2. A version (Fig. 31) sold recently from Colnaghi's, London, currently in a private collection in Spain, discussed in Donald Garstang, "Two Idealized Heads of Young Girls," 56, and sold earlier at Christie's, London, December 11, 1992, lot 20.

3. A version in the Cummer Gallery, Jacksonville, Florida, reproduced in *Collection Catalogue,* 38.

4. A version that sold at Sotheby's Old

Master Drawings sale, London, January 18, 1984, lot 60.

5. An oval version, very close to our picture, that sold as a Boucher at Sotheby's Monaco sale, June 13, 1982, lot 86.

6. A version listed as formerly in the Contini-Bonacossi Collection, sold in the Gutmann sale, Paul Graupe, Berlin, April 12–14, 1934, no. 31, of which a photograph is available in the Witt Library, Courtauld Institute.

7. An engraved version by J. F. Poletnich, made between 1750 and 1780, reproduced in Pierrette Jean-Richard, *L'oeuvre gravé de François Boucher dans le Collection Edmond de Rothschild,* 355, no. 1476, as "La voluptueuse."

8. A pastel, attributed to Boucher, in the Pushkin Museum, reproduced in *Art Treasures in Russia: Monuments, Masterpieces, Commissions, and Collections,* 5, fig. 64.

9. A version (Fig. 32), also attributed to Boucher, sold at the Kraemer sale, Paris, June 2–5, 1913, no. 112, and identified as one copy of the pastel by Boucher from the Bergeret Collection, although Shapley 1973, 158, is skeptical that the Kraemer pastel was after the Bergeret Boucher.

10. A version, attributed to Boucher (see no. 9 above), in the Bergeret Collection and sold in the Bergeret sale in 1785, now presumably lost.

11. A version, now thought to be of the nineteenth century, in the Taft Museum, Cincinnati, discussed by Leslie Griffin Hennessey in *The Taft Museum: Its History and Collections,* 286–89.

12. A version in pastel, attributed to Boucher, sold at the Cels sale, Giroux, Brussels, April 8, 1933, no. 174, of which a photograph is in the Witt Library, Courtauld Institute.

13. A version in pastel, attributed to Boucher, sold at the Lepke Sale, November 6–7, 1928, no. 359, of which there is a

photograph in the Witt Library, Courtauld Institute.

14. A version, in mezzotint, attributed to Boucher, from the Drouot sale, Paris, December 21, 1908, of which a photograph exists in the Witt Library, Courtauld Institute.

15. A version that appears hanging on a wall of a room depicted in an etching by Daniel Chodowiecki (1726–1801) titled "Cabinet d'un Peintre," a copy of which is in the portfolio of Chodowiecki's etchings in the Metropolitan Museum, no. 23.74, reproduced by Gudrun Calov, *Museums Kunde,* 47, fig. 11 (cited by Shapley 1973, 158, n. 3).

16. A version listed by Shapley 1973, 158, n. 3d, an oil at Archangelskoye, the former Yussupov estate near Moscow.

17. A version with the rose and pillow, most likely a copy after Rotari, offered for sale (lot 172) at Sotheby's Arcade Auction, New York, January 8, 1998, listed as "attributed to Pietro Antonio Rotari."

There appear to be three main types among these seventeen paintings, all of which depict the same sitter leaning her head back as she gazes down at the viewer.

The first type, an example of which hangs in the "Rotari Room" in the Peterhof (no. 1 above), shows the girl wearing a fur cap, but no flower of any kind. The second type, of which the Boucher pastel (see Fig. 32) is an example, shows the sitter with no hat, but with a large rose inserted into the bodice of the dress to the viewer's right. In this type, which has the most examples, the sitter usually has a pillow behind her head. Included in this group is the engraving produced in Paris between 1750 and 1780 by J. F. Poletnich (no. 7 above). Unique among all versions of this head, it portrays the sitter with a closed rather than an opened mouth. The third type exists in at least five examples, including our painting, the former Colnaghi painting (no. 2 above), the picture formerly in the Contini-Bonacossi Collection (no. 6 above), and a copy recently sold at Sotheby's (no. 5 above). All of these include a draped chairback behind the young woman's head and a sprig of jasmine either tucked in her bodice or held in her hand.[9]

JUDITH MANN

9. I wish to express my appreciation to Leslie Hennessey for her generous and kind assistance in sharing her knowledge and in helping to sort out these versions, and to Dr. Anthea Brook of the Witt Library, Italian Section, Courtauld Institute, London, for her diligence in tracking down many of these citations and reproductions for me.

14 Anonymous Imitator of Rembrandt

Holland: last half of seventeenth century

Abraham's Sacrifice of Isaac (ca. 1650–1675?)

Oil on canvas. 183.6 × 132.8 cm. Museum of Art and Archaeology, University of Missouri–Columbia (61.83), Samuel H. Kress Collection (K 1633).

Provenance: Sir Frederick Cook, Doughty House, Richmond, Surrey, England, and through succession to the Sir Herbert Cook Collection; Contini-Bonacossi Collection, Florence; Samuel H. Kress Foundation (1949).

Literature: Eisler, 140–41; *Illustrated Museum Handbook*, 77–78; J. Bruyn et al., *A Corpus of Rembrandt Paintings*, vol. 3, *1635–1642*, 112.

Our painting represents a moment in the story of Abraham (Gen. 22:1–14). As a test of Abraham's faith, God tells him to take his son Isaac into the land of Moriah, where, God says, he will be shown a certain hill. On this hill Abraham is to make a burnt offering of Isaac to God. Abraham obediently takes Isaac to Moriah and, finding the hill, makes preparations for the sacrifice. At the last moment, just as Abraham is about to kill his son, an angel appears and stops him.

In keeping with the narrative, the figures of the angel, Abraham, and Isaac in our painting are elevated above a landscape with another hill in the distance. The angel dramatically enters the scene from the upper-left-hand side and grasps Abraham's hand, causing him to drop his jeweled dagger, which is depicted in midair. Abraham's body is jerked backward by the angel's action, but he has not yet released his son. Isaac, whose arms are bound behind him, lies helplessly on the altar, pinned under the powerful grip

of his father's massive hand, which covers his face like a mask.

Our painting is probably a copy of Rembrandt's original version in the Hermitage in St. Petersburg (Fig. 33), signed and dated "Rembrandt. f. 1635." Although the two pictures have nearly the same dimensions, there are important differences between them. For example, perhaps because it is abraded, our painting lacks some of the details of landscape and costume found in the original. Moreover, the facial expressions of the figures are not precisely the same in both versions. The painting in the Hermitage (and hence our picture) reflects both a composition by Pieter Lastman (1583–1633), one of Rembrandt's teachers, now in the Rijksmuseum, Amsterdam, and one by Jan Lievens (1607–1674) in the Galleria Doria, Rome.

Rembrandt was apparently dissatisfied with the composition of the painting in the Hermitage and reworked it in a drawing now in the British Museum, London (Fig. 34).[1] A pupil, presumably the Mennonite artist Govert Flinck (1615–1660), used the drawing to make another version of the subject, now in Munich (Fig. 35).[2] Rembrandt endorsed the Munich painting with an inscription at the bottom: *Rembrandt. verandert. En overgeschildert. 1636* ("Rembrandt. revised. And painted over"), which suggests that the master corrected and repainted the work of his pupil.[3] The composition of both the drawing in London

1. Some scholars believe the drawing is not by Rembrandt but is after one of his paintings. See Ernst Brochhagen and Brigitte Knüttel, *Holländische Malerei des 17. Jahrhunderts, Alte Pinakothek, München, Katalog III*, 74.

2. For a discussion of all of these versions and their sources, see J. Bruyn et al., *A Corpus of Rembrandt Paintings*, vol. 3, *1635–1642*, 101–13, and *Dictionary of Art*, 26:157.

3. The inscription is not universally accepted as authentic.

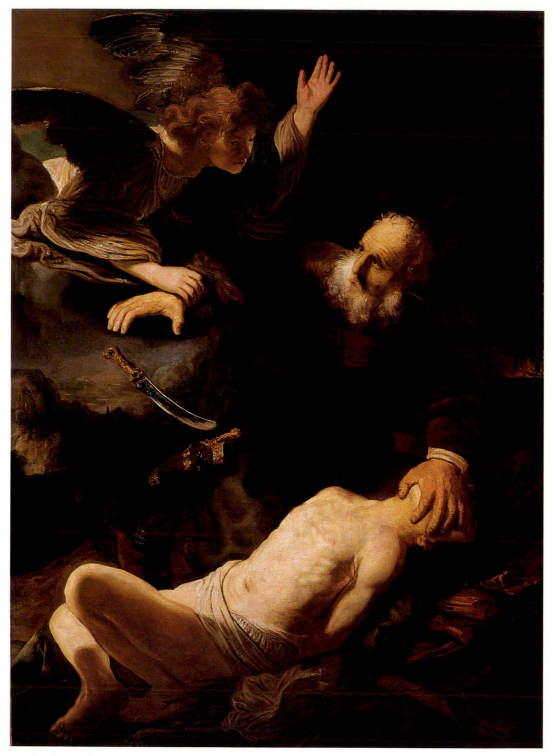

Cat. No. **14.** *Anonymous Imitator of Rembrandt.* Abraham's Sacrifice of Isaac. *Museum of Art and Archaeology, University of Missouri–Columbia; Gift of the Samuel H. Kress Foundation.*

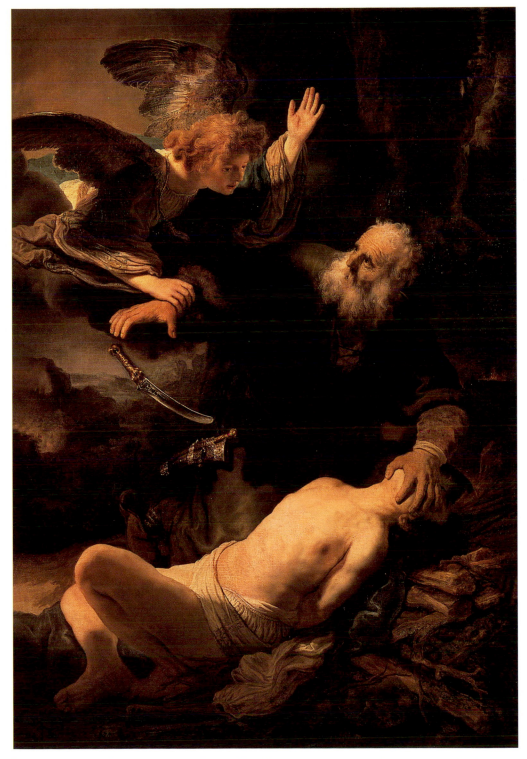

Fig. **33.** *Rembrandt.* The Sacrifice of Isaac. *The Hermitage, Saint Petersburg. (Photo: Art Resource)*

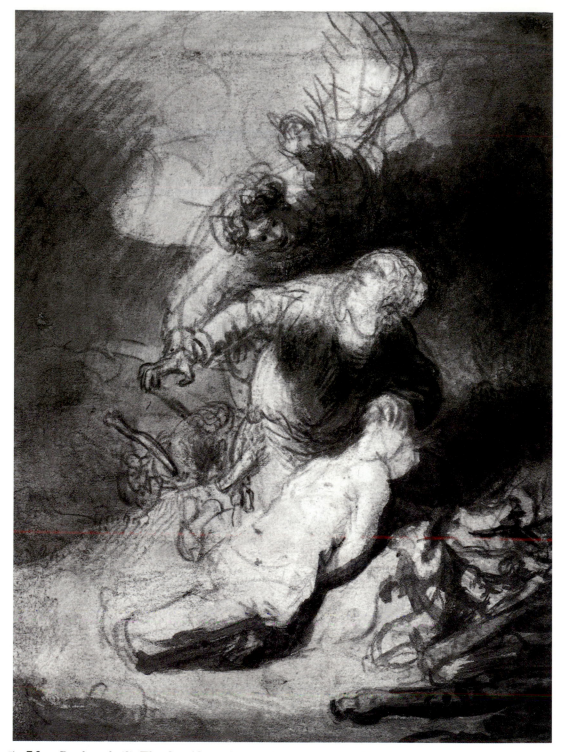

Fig. **34.** *Rembrandt (?)*. The Sacrifice of Isaac. *Drawing (red and black chalk, wash and white body color on paper). The British Museum, London. (Photo: British Museum, London)*

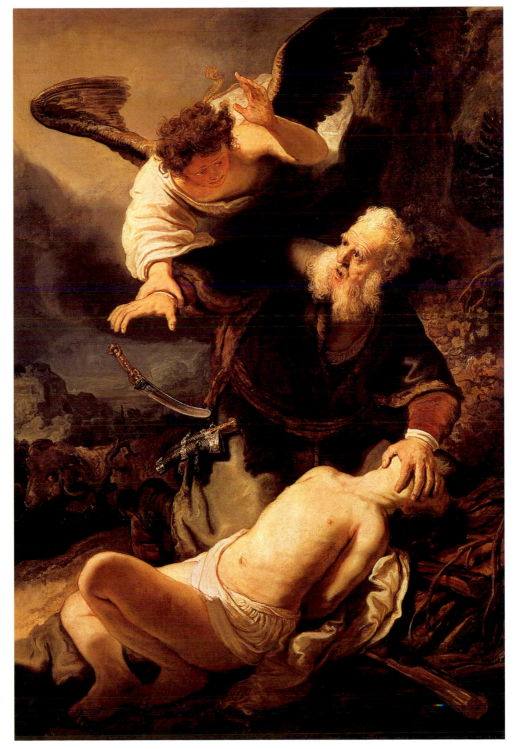

Fig. **35.** *Rembrandt and Govert Flinck (?)*. The Sacrifice of Isaac. *Bayersche Staatsgemaldesammlungen, Munich. (Photo: Art Resource)*

and the painting in Munich, especially the placement of the angel behind Abraham, echoes an engraving of 1614 by Andreas Stock after a painting by Peter Paul Rubens (1577–1640) in the Nelson-Atkins Museum of Art, Kansas City (Fig. 36).[4]

The drawing in the British Museum (Fig. 34) and the Munich painting (Fig. 35) differ significantly from our painting. For example, there is a ram to the left of and behind Abraham in the Munich picture, but not in our painting or in the drawing in London. Moreover, in the Hermitage version (Fig. 33), the angel seems suspended, floating aloft, and the drama of the moment focuses not so much on the movement of the entire angel as on his hand, which forcibly restrains Abraham by grasping his wrist and causing him to drop his knife. The action of dropping the knife is repeated in our version but is given more importance by the dramatic entry of the angel, who, rather than approaching Abraham unobtrusively from behind, bursts into the scene. Arriving in the nick of time at Abraham's side, he saves Isaac from certain death. The angel's upraised left hand is prominently silhouetted against the dark background. This gesture seems as important in staying the sacrifice as the act of grasping Abraham's hand.

Unfortunately, the identity of the artist responsible for our work has not been established with certainty. The uncertain attribution is in part due to the condition of our painting. Portions of the surface have been heavily restored after aggressive overcleaning at some point in its past. In particular, the figure of Isaac, Abraham's left hand, and parts of the background have been retouched. Vertical abrasions on both the left- and the right-hand borders suggest that the canvas was at one point folded over a smaller stretcher before it was returned to its original dimension. In addition, there is a horizontal line across the center of the picture caused by a seam in the original canvas. A horizontal seam in the canvas of the Hermitage picture (Fig. 33) was also evident before its restoration, but X-ray photographs of our painting do not indicate the kind of reworking that is typical of Rembrandt's original pictures.[5]

The abraded condition and subsequent retouchings of the picture explain in part its more cursory handling in comparison to authentic pictures by Rembrandt or works by his immediate followers. What may once have been a picture close in style to Rembrandt is now in such a state of restoration that we cannot warrant placing it directly within the artist's immediate circle of influence. Nevertheless, although the old canvas has been relined, the original support and the technique of the painting are consistent with the materials and methods of other seventeenth-century artists. In addition, the materials used in making the picture reinforce the stylistic evidence that it is a seventeenth-century Dutch painting. The ongoing work of the Rembrandt Research Project and of other scholars makes it clear that many of the copies of and imitations after Rembrandt's pictures previously thought to have been made during the eighteenth or nineteenth century are in fact from the seventeenth century.

BURTON DUNBAR

4. Rembrandt later returned to the subject of the sacrifice of Isaac in an etching of 1655. See Jakob Rosenberg, *Rembrandt: Life and Work*, 173, fig. 146, for a convenient illustration of the etching.

5. See Baumann in *Illustrated Museum Handbook*, 78.

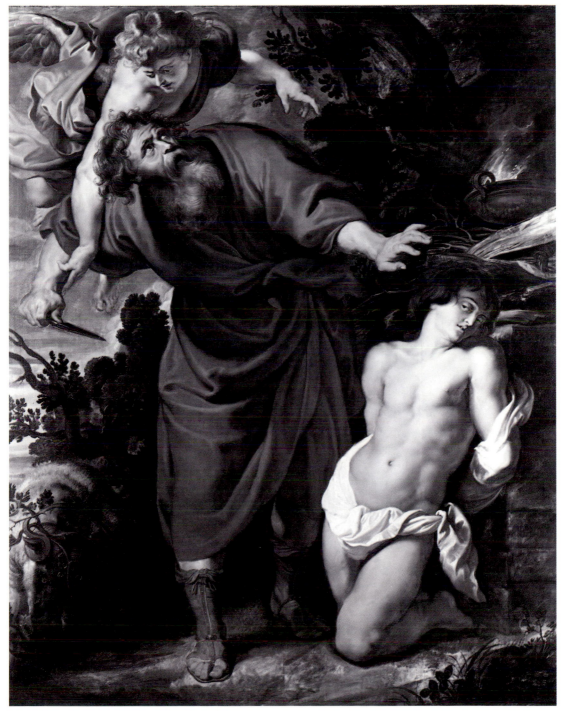

Fig. **36.** *Peter Paul Rubens.* The Sacrifice of Isaac. *Oil on canvas. Nelson-Atkins Museum of Art, Kansas City, Missouri. (Photo: Nelson-Atkins Museum of Art, Kansas City, Missouri)*

Contributors to the Catalog

Burton Dunbar, Professor, Department of Art and Art History, University of Missouri–Kansas City, Kansas City, Missouri

Norman E. Land, Professor, Department of Art History and Archaeology, University of Missouri–Columbia, Columbia, Missouri

Judith Mann, Curator, Early European Art, The Saint Louis Museum of Art, St. Louis, Missouri

Marjorie Och, Assistant Professor, Department of Art, Mary Washington College, Fredericksburg, Virginia

William E. Wallace, Associate Professor, Department of Art History and Archaeology, Washington University, St. Louis, Missouri

Bibliography

Alberti, Leon Battista. *On Painting and on Sculpture.* Edited and Translated by C. Grayson. London: Phaidon, 1972.

Alpers, Svetlana. *Rembrandt's Enterprise: The Studio and the Market.* Chicago: University of Chicago Press, 1988.

Apollodorus. *The Library.* Edited by J. G. Frazer. 3 vols. Loeb Classical Library. Cambridge and London: Harvard University Press, 1959.

Baxandall, Michael. *Shadows and Enlightenment.* New Haven and London: Yale University Press, 1995.

Béguin, Sylvie. "Paris Bordon en France." In *Paris Bordon e il suo tempo: Atti del convegno internazionale di studi,* 9–27. Treviso: Canova, 1987.

Belting, Hans. *The Image and Its Public in the Middle Ages: Form and Function of Early Paintings of the Passion.* Translated by M. Bartusis and R. Meyer. New Rochelle, N.Y.: A. D. Caratzas, 1990.

Berenson, Bernard. *Italian Pictures of the Renaissance: Venetian School.* 2 vols. London and New York: Phaidon, 1957.

———. *Homeless Paintings of the Renaissance.* Edited by Hanna Kiel. Bloomington and London: Indiana University Press, 1969.

Birbari, Elizabeth. *Dress in Italian Painting, 1460–1500.* London: J. Murray, 1975.

Boehn, Max von. *Modes and Manners, Ornaments: Laces, Fans, Gloves, Walking Sticks, Parasols, Jewelry, and Trinkets.* New York: Dutton, 1929.

Borenius, Tancred. "Saint Anthony and the Centaur in Two Predella Pictures by Bartolomeo Montagna." *Apollo Magazine* 5 (1927): 109–11.

Brochhagen, Ernst, and Brigitte Knüttel. *Holländische Malerei des 17. Jahrhunderts, Alte Pinakothek, München, Katalog III.* Munich: Bruckmann, 1967.

Bruyn, J., B. Haak, S. H. Levie, J. J. van Thiel, and E. van de Wetering. *A Corpus of Rembrandt Paintings.* Translated by D. Cook-Radmore. 3 vols. Dordrecht, Boston, and London: Martinus Nijhoff, 1989.

Cafritz, Robert C., Lawrence Gowing, and David Rosand. *Places of Delight: The Pastoral Landscape.* Washington, D.C.: Phillips Collection and National Gallery of Art, 1988.

Campbell, Lorne. *Renaissance Portraits: European Portrait-Painting in the 14th, 15th, and 16th Centuries.* New Haven: Yale University Press, 1990.

Canova, Giordana Mariani. *Paris Bordon.* Venice: Edizioni Alfiere, 1964.

———. "Paris Bordon: Problematiche chronologiche." In *Paris Bordon e il suo tempo: Atti del convegno internazionale di studi,* 137–57. Treviso: Canova, 1987.

Chace, Margaret Reynolds, ed. *A Gift to America: Masterpieces of European Painting from the Samuel H. Kress Collection.* New York: Abrams, 1994.

Collection Catalogue. Jacksonville, Fla.: Cummer Gallery of Art, 1965.

Cuttler, Charles D. "The Temptation of Saint Anthony in Art from Earliest Times to the First Quarter of the Sixteenth Century." Ph.D. diss., New York, 1952.

Dell'Acqua, Gian Alberto, and Germano Mulazzani. *L'opera completa di Bramantino e Bramante pittore.* Milan: Rizzoli, 1978.

Dictionary of Art. Edited by Jane Turner. 34 vols. London: Grove's Dictionaries, 1996.

Eisenberg, Marvin J. "A Processional Cross by Neri di Bicci." *Bulletin* (University of Michigan, Museum of Art) 7 (1956): 3–8.

Eisler, Colin. *Paintings from the Samuel H. Kress Collection: European Schools Excluding Italian.* Oxford: Phaidon, 1977.

Fiocco, Giuseppe. "Di Pietro Rotari (e d'un Libro che Lo riguarda)." *Emporium* 96:571 (1942): 276–280.

Fredericksen, Burton B., and Federico Zeri. *Census of Pre-Nineteenth-Century Italian Paintings in North American Public Collections.* Cambridge: Harvard University Press, 1972.

Freedberg, David. *The Power of Images: Studies in the History and Theory of Response.* Chicago and London: University of Chicago Press, 1991.

Freedberg, Sydney J. *Painting in Italy, 1500–1600.* 3d ed. New Haven: Yale University Press, 1993.

Friedmann, Herbert. *The Symbolic Goldfinch: Its History and Significance in European Devotional Art.* New York: Pantheon Books, 1946.

Garberi, Mercedes P. *Il Castello Sforzesco: Le raccolte artistiche: Pittura e scultura.* Milan, 1974.

Garstang, Donald. "Two Idealized Heads of Young Girls." In *Master Paintings, 1400–1800,* 56. London: D. Colnaghi Co., 1993.

Gombrich, Ernst Hans. *Shadows: The Depiction of Cast Shadows in Western Art.* London: National Gallery Publications, 1995.

Granville, Augustus Bozzi. *Saint Petersburg: A Journal of Travels to and from That Capital.* 2 vols. London, 1826.

Grassi, Luigi. "Ingegno di Altobello Melone." *Porporzioni* 2 (1950): 153–55.

Graves, Robert. *The Greek Myths.* Harmondsworth: Penguin, 1992.

Gregori, Mina. "Altobello e Gianfrancesco Bembo." *Paragone* 93 (1957): 32–33.

———, ed. *I Campi e la cultura artistica cremonese del Cinquecento.* Milan: Electa, 1985.

———, ed. *Pittura a Cremona dal Romanico al Settecento.* Milan: Casa di risparmio delle provincie Lombarde, 1990.

Habert, Jean Pierre. "Man with a Glove." In *Titian: Prince of Painters,* edited by S. Biadene, 190–92. Munich: Prestel, 1990.

———. "*Portrait de jeune homme* dit *L'Homme au gant.*" In *Le siècle de Titien: L'âge d'or de la peinture à Venise,* 372–73. Paris: Réunion des musées nationaux, 1993.

Hall, James. *Dictionary of Subjects and Symbols in Art.* Rev. ed. New York: Harper and Row, 1974.

Hennessey, Leslie Griffin. "Head of a Girl." In *The Taft Museum: Its History and Collections,* edited by E. J. Sullivan, 286–89. New York: Hudson Hills Press, 1995.

Herald, Jacqueline. *Renaissance Dress in Italy, 1400–1500.* London: Bell and Hyman, 1981.

Hibbard, Howard. *Bernini.* Harmondsworth: Penguin, 1965.

Hollander, Anne. *Seeing through Clothes.* New York: Viking Press, 1978.

Hunt, John Dixon, ed. *The Pastoral Landscape*. Studies in the History of Art, 36. Hanover and London: University Press of New England, 1992.

Ivanoff, Nicolai. *Bazzani*. Mantua: L'Ente Provinciale per il turismo, 1950.

Jameson, Anna. *Legends of the Monastic Orders*. London, 1867.

———. *Sacred and Legendary Art*. 2 vols. Boston and New York, 1899.

Jean-Richard, Pierrette. *L'oeuvre gravé de François Boucher dans le Collection Edmond de Rothschild*. Paris: Editions des musées nationaux, 1978.

Joinville, Jean de. *Histoire de S. Loys IX du nom, roy de France*. Paris, 1617.

Kennett, Audrey. *The Palaces of Leningrad*. New York: Putnam, 1973.

Kurz, Otto, and Ernst Kris. *Legend, Myth, and Magic in the Image of the Artist: A Historical Experiment*. New Haven and London: Yale University Press, 1979.

Land, Norman E. "Two Panels by Michele Giambono and Some Observations on St. Francis and the Man of Sorrows in Fifteenth-Century Venetian Painting." *Studies in Iconography* 6 (1980): 29–51.

———. *The Viewer as Poet: The Renaissance Response to Art*. University Park: Pennsylvania State University Press, 1994.

———. "Romanino and the 'Shadows of Death.'" *Source: Notes in the History of Art* 16:1 (1996): 25–28.

———. "Carlo Crivelli, Giovanni Bellini, and the Fictional Viewer." *Source: Notes in the History of Art* 18:1 (1998): 18–24.

Leonardo da Vinci. *The Literary Works of Leonardo da Vinci*. Edited by Jean Paul Richter. 2 vols. London: Phaidon, 1970.

Lloyd, Christopher. *A Catalogue of the Earlier Italian Paintings in the Ashmolean Museum*. Oxford: Clarendon Press, 1977.

The Lost Books of the Bible and the Forgotten Books of Eden. Cleveland: Collins and World, 1977.

Manca, Joseph. *The Art of Ercole de' Roberti*. Cambridge and New York: Cambridge University Press, 1992.

Martin, John R. *Baroque*. New York, Hagerstown, San Francisco, and London: Harper and Row, 1977.

Maser, Edward A. "The Samuel H. Kress Study Collection Program." *Art Journal* 31:3 (spring 1962): 177–90.

Meiss, Millard. "Light as Form and Symbol in Some Fifteenth-Century Paintings." *Art Bulletin* 27 (1945): 43–68.

———. *Painting in Florence and Siena after the Black Death: The Arts, Religion, and Society in the Mid-Fourteenth Century*. New York: Harper and Row, 1964.

Merula, Paulus. *Santuario di Cremona*. Cremona, 1627.

[Michiel, Marcantonio.] *The Anonimo: Notes on Pictures and Works of Art in Italy Made by an Anonymous Writer of the Sixteenth Century*. Edited by G. C. Williamson. Translated by P. Mussi. New York: Benjamin Blom, 1969.

Mulazzani, Germano. *Il seicento lombardo: Catalogo dei dipinti e delle sculture*. Milan: Electa, 1973.

Myers, B. S., and T. Copplestone, eds. *Art Treasures in Russia: Monuments, Masterpieces, Commissions, and Collections*. New York: McGraw-Hill, 1970.

Newton, Stella Mary. *The Dress of the Venetians, 1495–1525*. Brookfield, Vt.: Scolar Press, 1987.

Orlandi, Pellegrino Antonio. *Abecedario pittorico*. Bologna, 1709.

Overby, Osmund, ed. *Illustrated Museum Handbook: A Guide to the Collections in the Museum of Art and Archaeology, University of Missouri–Columbia*. With contributions by J. C. Biers, R. G. Baumann, S. D. Nagar, R. Johnson, and R. E. Witt. Columbia and London: University of Missouri Press, 1982.

Polazzo, Marco. *Pietro Rotari pittore veronese del Settecento.* Verona: Il Segno, 1990.

Powell, Benjamin. *Erichthonius and the Three Daughters of Cecrops.* Cornell Studies in Classical Philology, 17. New York: Macmillan, 1906.

Puppi, Lionello. "Un'integrazione al catalogo e al regesto di Bartolomeo Montagna." *Antichità viva* 14 (1975): 23–29.

Réau, Louis. *Iconographie de l'art chrétien.* 3 vols. Paris: Presses Universitaires de France, 1959.

Richter, Jean Paul. "Ausstellung Alter Meister in Burlington House." *Kunstchronik,* 17:18 (1882): 286.

Rosenberg, Jakob. *Rembrandt: Life and Work.* Rev. ed. Ithaca: Cornell University Press, 1980.

Sacchi, Federico. *Notizie pittoriche cremonesi.* Cremona, 1872.

Schwartz, Michael. "Beholding and Its Displacements in Renaissance Painting." In *Placement and Displacement in the Renaissance,* edited by A. Vos, 233–54. Binghamton: Medieval and Renaissance Texts and Studies, 1995.

Shapley, Fern Rusk. "Valuable Art Collection for the University." *Missouri Alumnus* 49:8 (May 1961): 1–4

———. *Paintings from the Samuel H. Kress Collection: Italian Schools, XIII–XV Century.* London: Phaidon, 1966.

———. *Paintings from the Samuel H. Kress Collection: Italian Schools, XV–XVI Century.* London: Phaidon, 1968.

———. *Paintings from the Samuel H. Kress Collection: Italian Schools, XVI–XVIII Century.* London: Phaidon, 1973.

Shearman, John. *Only Connect . . . : Art and the Spectator in the Italian Renaissance.* Princeton: Princeton University Press, 1992.

Smith, David R. *Masks of Wedlock: Seventeenth-Century Dutch Marriage Portraiture.* Ann Arbor: UMI Research Press, 1982.

Steinberg, Leo. *The Sexuality of Christ in Renaissance Art and in Modern Oblivion.* 2d ed. Chicago: University of Chicago Press, 1996.

Thede, Christine E., and Norman E. Land. "Erotica veneziana: Paris Bordone's *Athena Scorning the Advances of Hephaestus." Muse: Annual of the Museum of Art and Archaeology, University of Missouri, Columbia* 27–28 (1993–1994): 41–48.

Thornton, Peter. *The Italian Renaissance Interior, 1400–1600.* London: Weidenfled and Nicolson, 1991.

Vasari, Giorgio. *Lives of the Painters, Sculptors, and Architects.* Translated by Gaston du C. de Vere. 2 vols. New York and Toronto: Alfred A Knopf, 1996.

Welch, Evelyn. *Art and Society in Italy, 1350–1500.* Oxford and New York: Oxford University Press, 1997.

Weller, Allen Stuart. "John Pickard, Walter Miller, the College Art Association of America, and the University of Missouri." In *100 Years of Teaching Art History and Archaeology, University of Missouri–Columbia, 1892–1992,* 6–37. Columbia: Department of Art History and Archaeology and Museum of Art and Archaeology, 1992.

Wildeblood, Joan. *The Polite World: Guide to the Deportment of the English in Former Times.* London: Davis-Poynter, 1973.

Wildenstein, George. "Un Amateur de Boucher et de Fragonard: Jacques-Onésyme Bergeret." *Gazette des Beaux-Arts* 58 (1961): 39–84.

Wittkower, Rudolf. *Art and Architecture in Italy, 1600 to 1750.* 1958. 2d ed. Baltimore: Penguin, 1977.

Zamboni, Silla. *Pittori di Ercole I d'Este.* Milan: Silvana, 1975.

Zanon, Sonia. "Documenti d'archivio su Zanino di Pietro." *Arte Veneta* 48 (1996): 108–17.

Zeri, Federico. "Altobello Melone: Quattro tavole." *Paragone* 39 (1953): 40–44.

Index of Artists and Works